CONTEMPORARY JAPANESE BAMBOO ARTS

Robert T. Coffland

Photographs by Pat Pollard

Portraits by Art Streiber

Art Media Resources with Tai Gallery

Acknowledgements

This book would never have existed without Lloyd Cotsen, who asked me to look for bamboo baskets. I am forever grateful to him for his guidance and support. This book would not be the same without my wife, Mary Hunt Kahlenberg, her sharp eye for beauty and editorial content. Melody Sumner Carnahan, as my editor, has made it so much less painful to put words on paper. If not for Gary Walters the editor in chief and Amy Koblenzer the picture editor of *Departures* magazine, the wonderful portraits by Art Streiber would not have been a part of this book. *Departures* is published by American Express for their Platinum customers. Shannon Francis, Mando Gonzales, and Joe Pugliese, who were all delightful traveling companions, assisted Mr. Streiber. A special thank you to Jo Durden-Smith who wrote the text for the *Departures* article. His questions gathered new insights into several of the artists. I could never have completed this book without Okada Koichiro's translation and interpreting skills. Also, over the years, Fujimatsu Iku and Ifshin Chako have been of invaluable assistance. I want to thank Priscilla Anton and Nancy Mackey for all their patience and back-up support during this project. In Japan I have been blessed with a group of terrific interpreters including Fuyuno Etsuko, Kurihara Hiromi, Kurihara Yumi, Morimoto Yasuyo, Tsukada Yoko, and Yokoyama Naoko. Through the meetings with the basket makers and travels with them, I have learned much about Japanese culture. Lastly, I would like to thank all of the bamboo artists in the book who patiently answered endless questions.

Japanese names are given in traditional order, surname first. For example, "Maeda" is the family name in Maeda Chikubōsai II.

All of the portraits of the artists are by Art Streiber, with the exception of Suemara Shobun's portrait by an unknown photographer.

Editor: Melody Sumner Carnahan
Creative Editor: Mary Hunt Kahlenberg
Translation: Okada Koichiro
Design, production and printing: C A Design, Hong Kong

Copyright 1999 Textile Arts Inc. and Art Media Resources

Published by Art Media Resources
1507 South Michigan, Chicago, IL 60605
info@artmediaresources.com
www.artmediaresources.com
in association with Tai Gallery
1571 Canyon Rd., Santa Fe, NM 87501
www.textilearts.com

ISBN 1-878529-66-8 Hardcover
ISBN 1-878529-67-6 Softcover

Front Cover: Monden Kyōgoku, **Flower of Waves**, 1977 21" diameter x 17" (53 x 43 cm)
Back Cover: Yako Hodō, **Autumn Scene**, 1998 10 1/2" x 4 1/2" x 16" (27 x 11 x 41 cm)

Contents

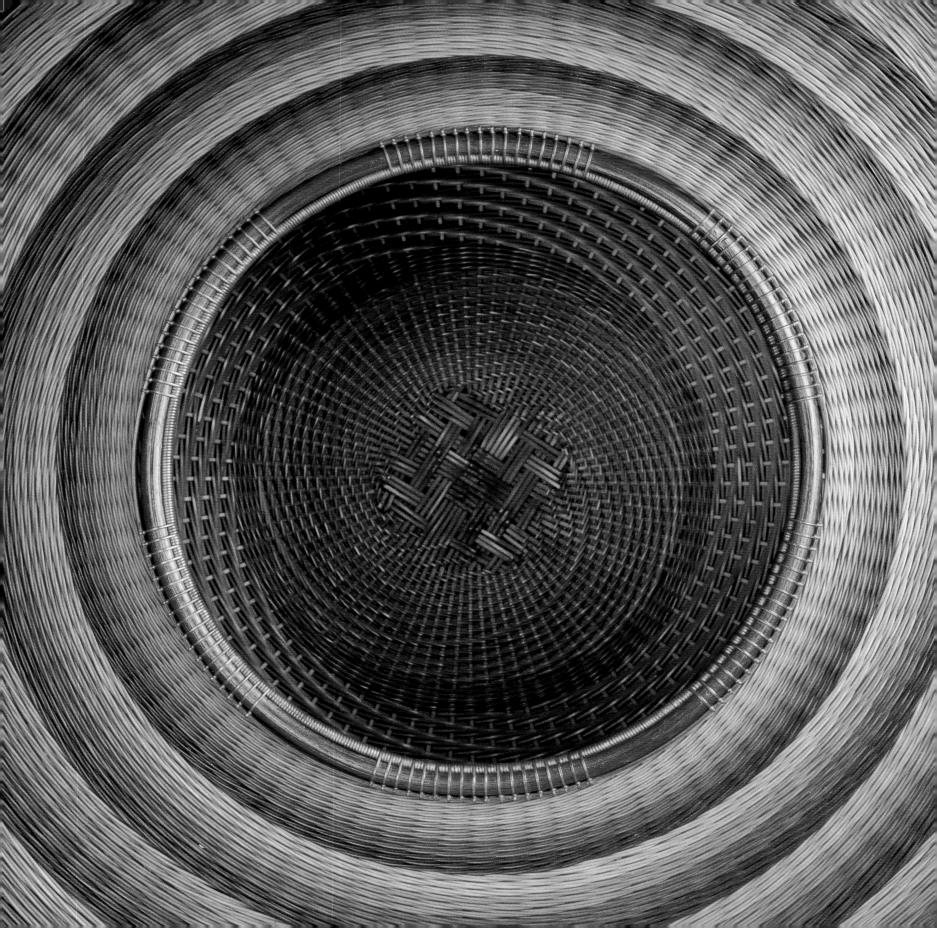

This book is dedicated to my wife, Mary Hunt Kahlenberg,
who has helped me to make many dreams come true.

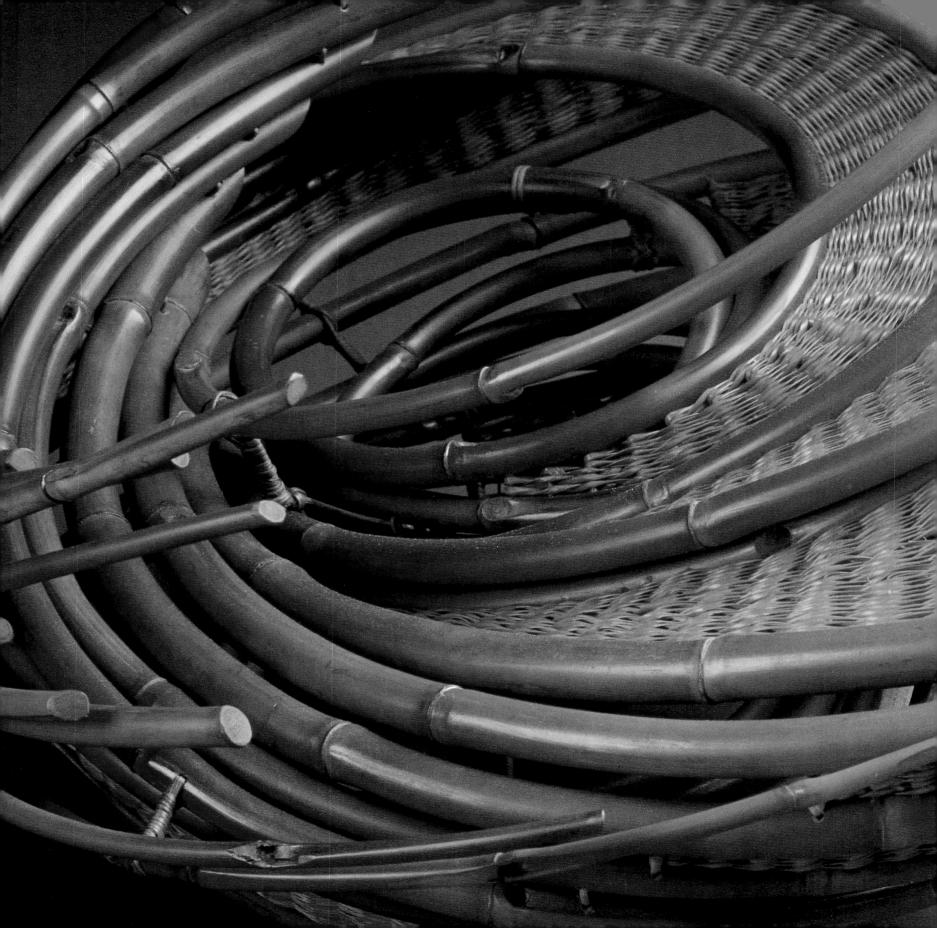

Contemporary Japanese Bamboo Arts

SEVERAL YEARS AGO a respected friend, Lloyd Cotsen, suggested I find unusual bamboo baskets for him on my visits to Japan. This struck me as an impossible task since Mr. Cotsen had been collecting for nearly forty years and already had over 700 Japanese bamboo baskets.

In order to go "basket hunting" for him I decided it would be important to study his collection, which at the time was primarily comprised of signed and unsigned works from the first half of the twentieth century. Mr. Cotsen once remarked to me that he was continually amazed by what a human being could do with a stick of bamboo. The more time I spent with these objects the more I too was impressed with the range of creativity.

On my first basket-hunting excursion, Mr. Cotsen asked me to purchase for him one basket of my choice. If I found other baskets I liked I was to take pictures. I visited antique shops in Tokyo and Kyoto. Needless to say, there were lots of baskets that seemed similar to baskets already in the Cotsen collection. Still, I managed to find a few unique baskets to photograph beyond my purchase of a nineteenth-century tea ceremony sweet tray.

Prior to my next trip, I again spent time studying his collection. Chikubōsai, Chikuryūsai, Chikuunsai, Rōkansai, Shōkosai, and Waiichisai became familiar names. The regional styles of the Kantō, Kansai, and Kyūshū started to become apparent. I found I especially enjoyed the work of a living artist by the name of Higashi Takesonosai. My wife, Mary Hunt Kahlenberg, had featured Higashi's work in *A Book about Grass: Its Beauty and Uses*. She had introduced Mr. Cotsen to Higashi's work in the 1970s, and since then he had collected more than twenty pieces. The bold contemporary statements in Higashi's work sparked my curiosity. Was he an anomaly or were there other bamboo artists creating innovative works in Japan?

Next I met with Sekijima Hisako, a Tokyo artist. She introduced me to Katsushiro Sōhō, a bamboo artist she deeply admired. Katsushiro lives two hours north of Tokyo on his family farm. I was overwhelmed by the originality of his artistry and I advised Mr. Cotsen to purchase his work, which he did. This experience fueled my desire to seek out other living bamboo artists in Japan.

My search has taken me from the remote island of Sado to the bamboo forests of Kyushu. What I discovered is that there are less than a hundred working bamboo artists in Japan. It is an art that is in danger of disappearing. This was not always the case.

Bamboo is as deeply intertwined as rice in Japanese history and culture. The emerging springtime bamboo shoots remain a gourmet treat. References to bamboo permeate poetry, literature, and music. Formerly, bamboo as a material found its way into almost every aspect of daily life. Bamboo's characteristics of lightness, strength, and flexibility, plus its natural sheen, have led to its utility as construction material, rope, fencing, fish and animal traps, bows and arrows, fly fishing rods, farm and garden tools, furniture, kitchen implements, musical instruments, religious articles, and of course, for baskets.

At one time, there were thousands of bamboo artisans throughout Japan who supplied these articles. Some belonged to an itinerant class that traveled from town to town. Others were farmers and their wives who made bamboo articles during the winter season to gain extra income. Starting in the Edo period (1615-1867), the most talented artisans were asked by tea ceremony masters to make copies of classical Chinese bamboo baskets for flower arrangements — an important part of tea ceremony furnishings and protocol. From that pool of talent, artists emerged who created original works for the upper classes. The patronage of wealthy clients helped to bring about a blossoming of bamboo arts at the end of the nineteenth century.

Also important to the development of modern bamboo craft was the Meiji Restoration. The new Meiji government encouraged industry and foreign trade. Japanese arts and crafts were displayed at World's Fairs starting with London in 1862, which led to an increased international demand for all kinds of Japanese goods including bamboo baskets. The government sponsored Domestic Industry Exhibitions at which awards were given in recognition of excellence in various crafts. Basket dealers in Yokohama formed export businesses, which brought about the making of standardized baskets involving a division of labor. The Meiji government also established vocational schools for teaching traditional Japanese crafts.

The general increase in economic activity during this period led to a dramatic expansion of the middle classes. This group turned to tea ceremony and flower arranging in its pursuit of a cultured life. More people had leisure time to travel to hot springs resorts and other tourist destinations. When commercial sea service was established to the hot springs town of Beppu on Kyushu, it became a popular destination, and tourists returned home carrying souvenirs of simple locally made bamboo baskets.

The Domestic Industry Exhibitions continued into this century and then the Ministry of Agriculture and Commerce established a new organization named Nōten. Design and functional art by craftsmen were exhibited. In 1907 the government sponsored an event named Bunten, which featured only painting and sculpture. As there had never been the kind of art hierarchy in Japan such as had evolved in the West, the craft artists began to lobby for their inclusion in the exhibition. In 1927 the craft artists succeeded when Nōten was re-organized into a new organization named Teiten. The first bamboo artists were included in 1929. This event is noteworthy because it reveals a strong desire on the part of bamboo artists to have their work seen as art.

The fact that bamboo baskets had a functional use complicated the question. At the heart of the debate about the inclusion of craft arts was whether the art content was higher than the craft. Consequently, the inclusion of bamboo arts as part of Teiten gave the best artists a challenging environment in which to compete. However, very few bamboo artists were selected to have their work exhibited. Some prejudice persisted against the bamboo arts. After World War II, Teiten was reorganized into Nitten (Japan Fine Arts Exhibition or *Nihon Bijutsu Tenrankai),* which was more favorable to bamboo arts.

There are five divisions in the Nitten organization with bamboo being in the craft arts division. The attainment of full Nitten membership is a long process for artists in any of the mediums. The first step being to join an artists' group which holds spring exhibitions. Bamboo artists belong to either the Japan Modern Craft Arts Association (*Nihon Gendai Kōgeikai*), which is the largest, or the Japan New Craft Arts Association (*Nihon Shin Kōgeikai*). With the recommendation of leaders in the chosen group, an artist will submit work to the fall Nitten exhibition. After being admitted to show ten times, one becomes an associate member. To become a full member, one must win two Grand prizes (*Tokusen*) and be accepted by the board of directors. Upon becoming a full member the artist's work is automatically admitted for exhibition. This takes decades and few are successful.

Exhibition pieces are typically developed over the course of one or two years. Drawings are made, and rough models might be constructed. Patience and tenacity play a major role in the life of every bamboo artist. Younger people may be initially attracted to the field and later give up, because they lack these personality qualities. A gifted young potter can create important works and be making a living years before a bamboo artist is just starting to develop a career. Often, I find myself in awe that there are any younger people at all coming into the field. One does not become a bamboo artist to make money, but from a deep connection and a love of the material and the process.

After learning the basics an ideal way for a bamboo artist to begin a career might go something like this. A master bamboo artist, a tea ceremony master, or a bamboo basket wholesaler would provide the artist with orders for simple traditional baskets. The making of these simple baskets is crucial for the artist as it helps to internalize the techniques. Over the course of a year, he or she finds the necessary two to three months to create an original work for submission to be exhibited at either the Nitten or Japan Traditional Craft Arts Exhibition. If the artist has time, work might be submitted to more than one show. There is no expectation that such works will sell at these exhibitions, the function of submitting works is to make a statement about the artist's dedication and creativity.

The artist eventually gains membership in a chosen arts organization, while at the same time builds a network of supporters. Ideally, the artist wins an award, which leads to a piece being acquired by a museum or an important collector. Status and position begin to grow. A critic might promote the artist's career. Concurrently, the artist continues to develop simple flower baskets reflecting a distinct approach and style. At this point, the artist begins to think about having a department store exhibition. Department stores provide a popular venue for artists of all types. Commercial galleries are far fewer in Japan and do not draw the numbers of visitors that department stores do. The department store displays the artist's pieces that were accepted in exhibitions as well as a large number of simpler flower baskets. Sales of smaller flower baskets make a department store exhibition successful. Japanese houses are much smaller than Western houses and there is no room to display larger pieces. It is, as I like to say, the smaller pieces that put rice in the bowl for all of the basket makers. If the artist becomes prominent some of the larger pieces begin to sell, and the artist is on the way.

The reality for many bamboo artists is far different. Honma Kazuaki started on a fast track in his twenties. Several pieces of his work were accepted for exhibition. He found time to create his bamboo art working night and day. However, his health failed in his early thirties. He realized he could not support his family without turning all of his energy to earning a living. This was in the 1950's when bamboo brooches were wildly popular. For the next ten years, he built up a business making these brooches and eventually employed fifty workers. The fad declined in the 1960's, but he already had an economic base. Only then did Honma again begin creating pieces for exhibition. He has now become a leading figure in the Nitten world.

Katsushiro Sōhō studied with a master for six years and then became independent. Over the next decade, he supported his family by making large bamboo baskets for shipping produce. After a few years cardboard boxes replaced bamboo baskets. Then he made bamboo brooches during the aforementioned fad. When that ended, he apprenticed with another teacher for several years. His big break came from a tea ceremony article shop that asked him to repair old bamboo flower baskets, which allowed him not only to make a living but also to learn from past bamboo artists. He also made simple flower baskets for the shop to sell.

Monden Kyōgoku's career halted when he was drafted into the army during World War II. After the War, the only way he could support his family was by making simple kitchen baskets for wholesalers in Osaka and Okayama. He would buy a truckload of green bamboo and he and his workers would set about making hundreds of the same style baskets. This was what he did for the next twenty-five years. Monden's business started to decline with the increasing popularity of plastics and the importation of cheaper baskets from other parts of Asia. His break came when a local department store asked him to put together an exhibition of his work.

Suemara Shōbun's promising career also stalled when he was drafted to work in a War-related industry. After the War, the company converted to making card tables. Suemara was not happy there, but at least he made a living for his family. However, his wife felt that this was a waste of his talent, and she secretly started to visit tea masters and flower arranging teachers. Eventually, she was able to get together enough orders to allow Suemura to quit his job and develop his own business.

Up until a few years ago Yako Hodō made bamboo light covers for a large electrical lighting company. Every year for twenty years he would get orders for about three hundred covers, which took him most of the year to fulfill. He never knew for certain when the orders would come, which meant planning for an exhibition at a department store was impossible. Five years ago, he could no longer tolerate the thought of making another light cover, so he quit and began exhibiting his work.

These and other personal stories make clear the difficulties that must be overcome to gain recognition in the field of bamboo arts. The supportiveness of spouses and other family members is extremely important. Often, a spouse will work at another job or simply accept a more humble lifestyle. Sometimes, parents will provide financial support. The inheritance of a parent's property has been a godsend to a number of bamboo artists. There is not a single bamboo artist I know of who could not be making more money doing something else. The time involved in the preparation of materials and the creation of the pieces insures a low wage. On top of this, Japan is one of the most expensive countries in the world.

What does the future hold? As I became more familiar with Japanese bamboo arts, I grew alarmed at the small numbers of younger people entering the field. Given the economic pressures and pleasures of modern life, and the necessary devotion required to a long period of learning, few young people are attracted. However, I have noticed a couple of trends that may augur well for the future. The first is that women are beginning to appear in greater numbers.

Kajiwara Aya has become the first woman bamboo artist to attain full membership status in the Japan Craft Arts Association. She started out by helping her husband fill orders given by local bamboo basket wholesalers. There are several other women who have had their work accepted at the Japan Traditional Craft Arts Exhibition. Often, they start out taking a hobby class in bamboo and then become serious in their studies. The women are frequently older with a husband who provides economic support. They may gain a little extra money by making simple flower baskets, but do not have to depend on it to support their families. This freedom could encourage experimentation and originality.

The second trend is that there are men in their fifties and sixties who have become interested in the art through the work of their fathers. Monden Kyōgoku's son, Yuichi, recently retired at fifty-five to pursue carrying forward his father's name. In another instance, Higashi Takesonosai's son, Kiyokazu, a government bureaucrat, produces bamboo art in his spare time. He has now had work accepted for exhibition in the Japanese Craft Arts Association. The longevity of Japanese people will work in the field's favor.

Another trend of importance to note is the increasing acceptance by the West of contemporary Japanese bamboo art. To no small degree, this is a source of wonder, amazement, and delight to all of the bamboo artists I know. The recession of the 1990's has been especially hard on all bamboo artists. Interest in tea ceremony and flower arranging has continued to decline. Earlier in the century, wealthy patrons provided artists with financial support in order to insure for themselves obtaining the best work. There are now few, if any, such patrons in Japan. If there is no way for an established bamboo artist to make a living, there is no way the field can attract people to continue the art. The enthusiastic response from museums and collectors in the West offers tremendous encouragement to all bamboo artists.

The bamboo arts indeed face an uncertain future in Japan, but I am convinced that there will be a future because bamboo has such a special appeal as a material. In doing the research for this book, I asked all of the artists involved to write statements about their relationships with bamboo. A particularly sensitive response came from Yamaguchi Ryūun in the following poem.

Robert T. Coffland
Santa Fe, October 1999

Bamboo is beautiful.
Bamboo grows rapidly.
I listen to the voice of bamboo.
It tells me many stories.
I learn to talk to bamboo.
I begin to express the beauty of bamboo.
I make the best out of bamboo.
I revive the life of bamboo in my work.
My work is made with the help of bamboo.

I feel the wind.
I enjoy the contrast of light and shadow.
It is beautiful how fire moves.
I wonder how to reveal that spacing in my patterns.
The beauty of the curved line.
The beauty of layers.
Talking to my creation.
To best make use of bamboo's resilience.
The beauty of simplicity.
The strength of wildness.

— Yamaguchi Ryūun, 1999

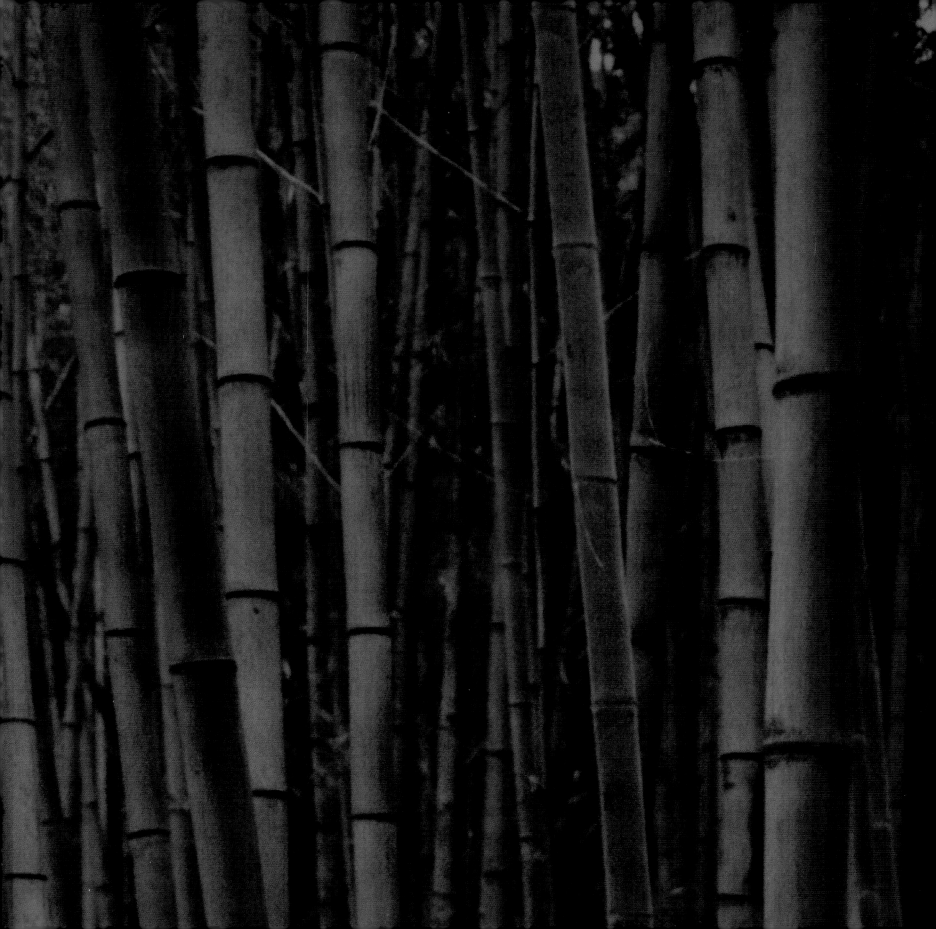

Artists of the
Japan Craft Arts Association

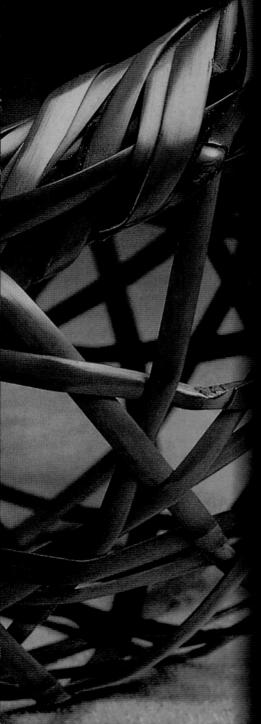

Iizuka Shōkansai was born into a family of bamboo basket makers as the second son of Iizuka Rōkansai, who was one of the most famous bamboo artists of the twentieth century. His father took the stance that his work was art not craft. Iizuka graduated in 1942 from the Tokyo University of Art with a major in oil painting. Soon after the death of his elder brother, he was asked to return to the family tradition to study bamboo art with his father. He describes this difficult time, "When I first made a basket after learning the basics, I took it to my father. He was quiet for awhile then suddenly jumped up and stamped on my basket. Another time, he cut my basket with scissors and others he put into the wood stove. He never told me what was wrong with a basket, but only told me to make another."

In 1947 Iizuka's work was accepted for exhibition in Nitten, where he thereafter exhibited twenty times, and became a full member in 1967. In 1974, after being commissioned by the Office of Imperial Household to make a basket for the new Guesthouse, he was admitted to the Japan Traditional Craft Arts Exhibition where he received the Minister of Education Award and continued to exhibit. He first became a judge in 1976. He was designated a Living National Treasure in 1982, the second bamboo artist to be so honored. His work was included in the exhibition *Living National Treasures of Japan* that toured Boston, Chicago, and Los Angeles in 1982-83. He has received numerous honors from the Japanese government, including the Order of Cultural Merit. He is currently the director of the bamboo category of the Japan Traditional Craft Arts Association, and his works are included in numerous important collections including the Tokyo National Museum of Modern Art.

Iizuka says of his art, "Bamboo is most beautiful when it is in nature. To split it, to strip it, to shape it, to express its beauty in the world of craft art is hard work but very rewarding. It has taught me a lot.

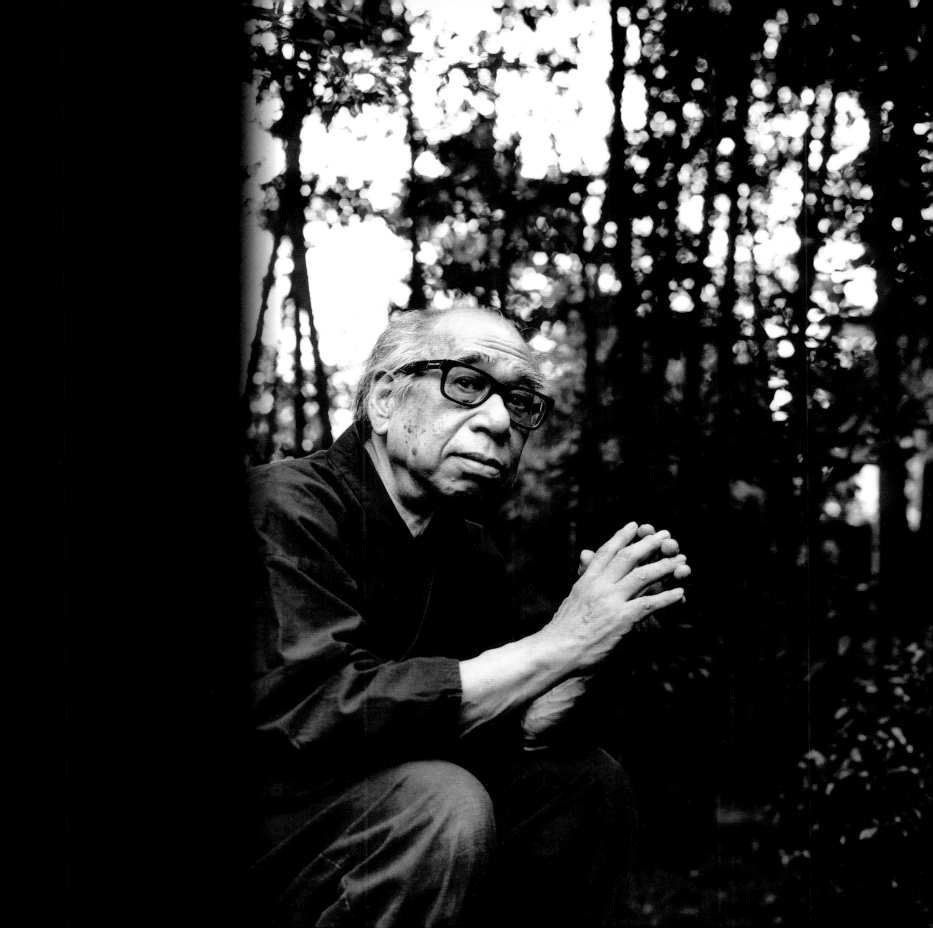

Iizuka Shōkansai

WIND IN THE PINES, 1993 14" diameter x 15" (36 x 38 cm)

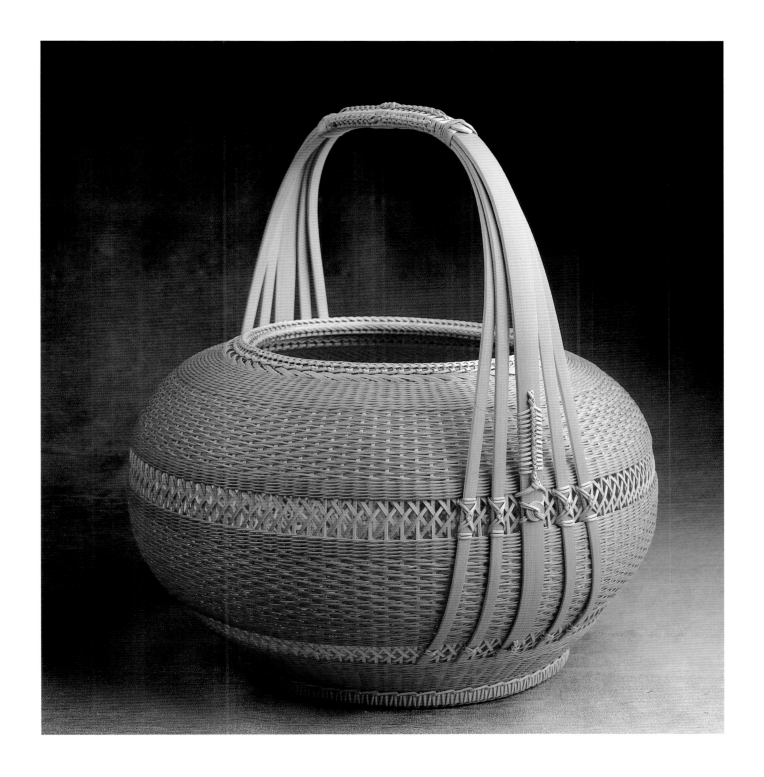

Iizuka Shōkansai

AFTERNOON NAP, 1979 10" diameter x 9" (25 x 23 cm)

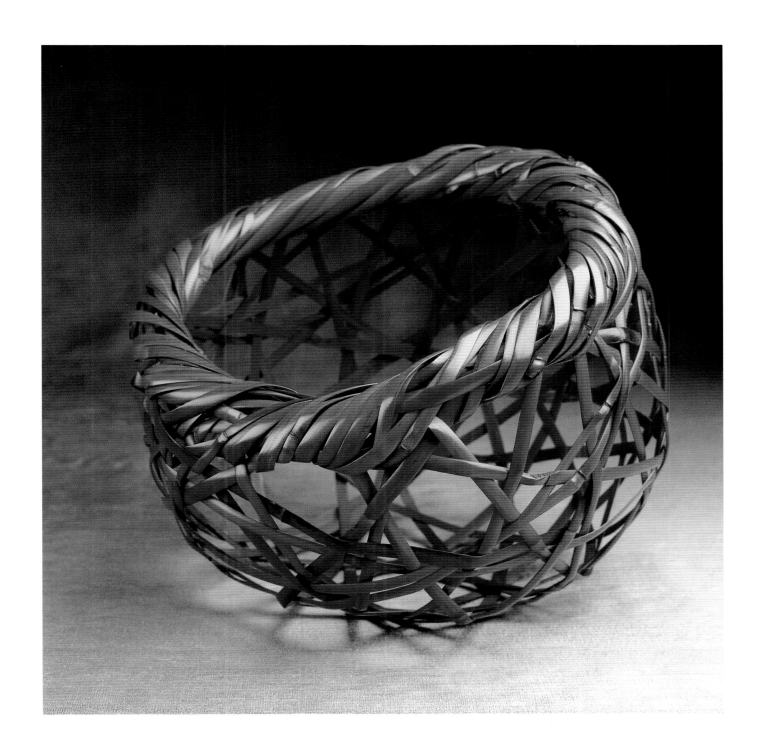

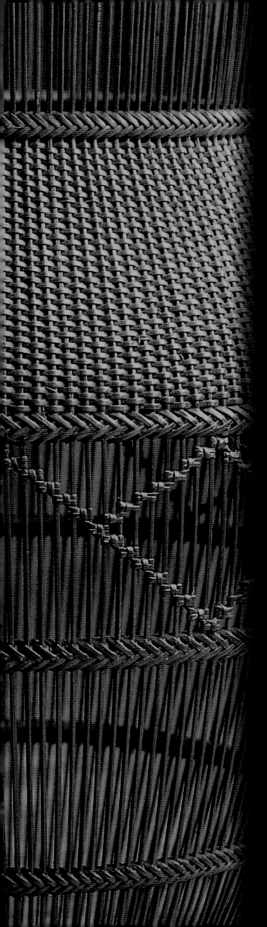

Maeda Chikubōsai II
born 1917, lives in Sakai, Osaka

Maeda Chikubōsai II was born late to Maeda Chikubōsai I. Chikubōsai I was pivotal in bringing individual expression to the bamboo arts. He didn't receive his father's attention right away but was instead taught by his father's students, then sent off on a business development tour of Korea and Hawaii. Finally, in 1945, after proving his sincerity to bamboo arts, he submitted his work to the Osaka Craft Exhibition, where he subsequently won eight awards.

In 1952 he succeeded to the Chikubōsai name and struck a new direction developing his own style of weaving involving extremely fine strips of bamboo woven into ingenious and eccentric forms. After asking advice from Iizuka Rōkansai, his work was accepted in Nitten in 1953 and subsequently accepted twelve more times. In the same year, a piece of his work was presented to the Emperor as a gift from the Governor of Osaka. His work has been part of numerous traveling exhibitions, including those to Germany, New Zealand, and Austria.

In 1959 he was admitted to the Japan Traditional Craft Arts Exhibition, thereafter exhibiting twenty-seven times, and in 1964 he was admitted to the Modern Craft Arts Exhibition. He became a full member of the Japan Craft Arts Association in 1972 and has since been a judge many times. In 1979 he participated in the *Japan Style* exhibition in England. Numerous awards and accolades followed in the next two decades, including the Order of Cultural Merit from the Japanese Government in 1992, and the supreme honor in 1995 of becoming the third bamboo artist designated a Living National Treasure.

Maeda says of his art, "I sometimes find myself wondering if the best piece I make will be my last or even if I have made it already. Bragging about your work is not good. An artist needs humility to make great art." He lives in Osaka and continues to exhibit surprising new works, "finding joy in making something different from others."

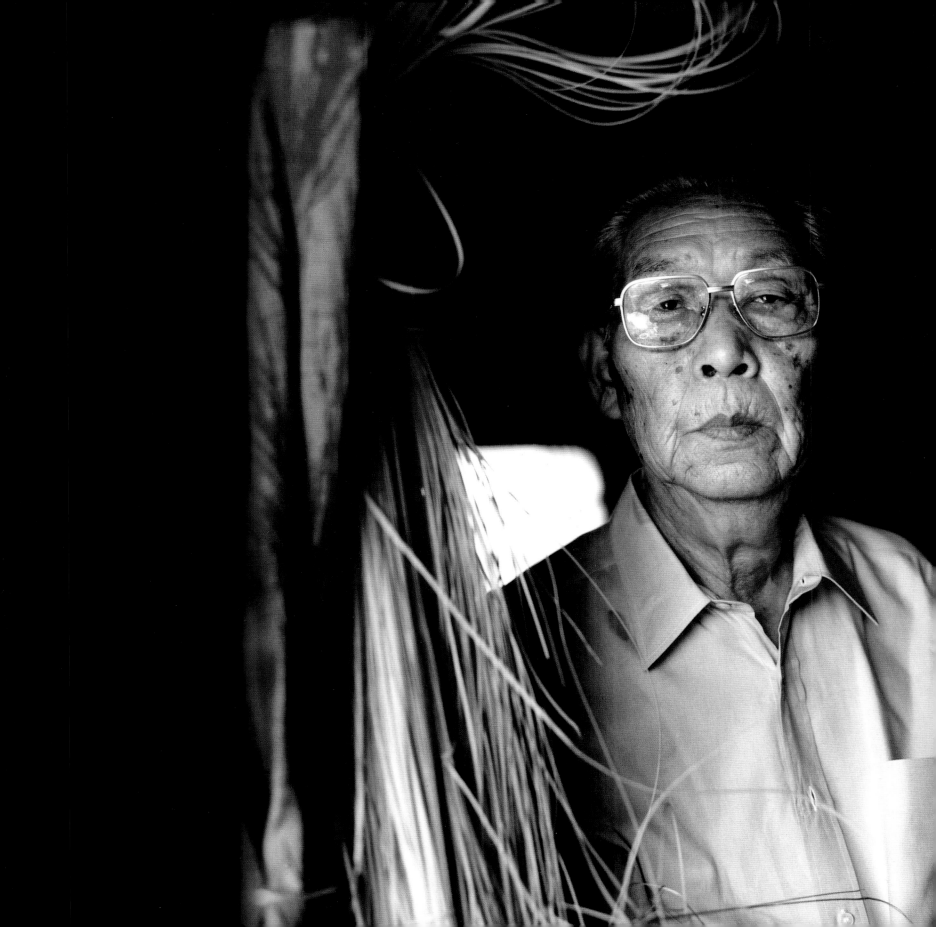

Maeda Chikubōsai II

BLESSING, 1969 7" diameter x 13" (18 x 33 cm)

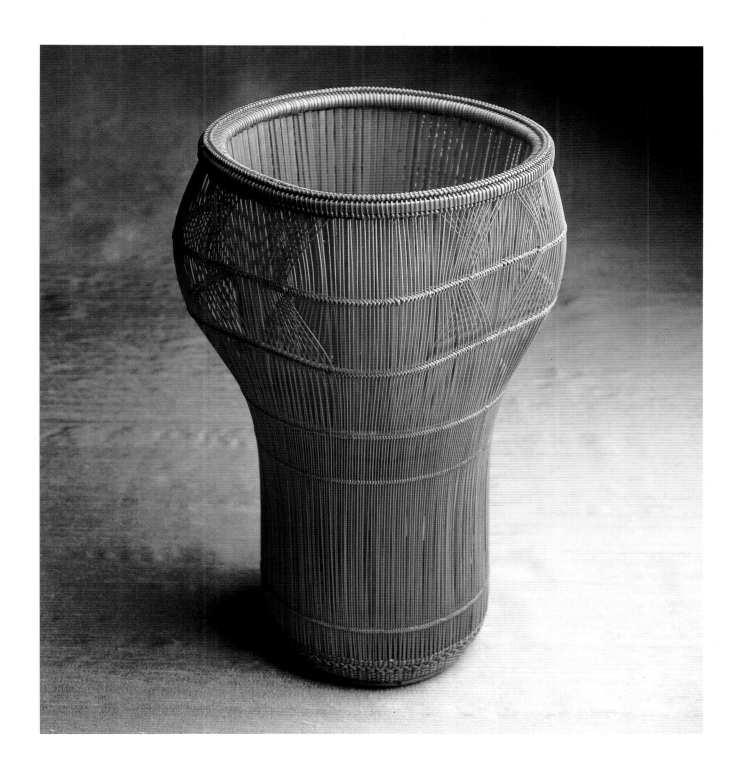

Maeda Chikubōsai II

UNTITLED, 1956 7″ diameter x 11″ (18 x 28 cm)

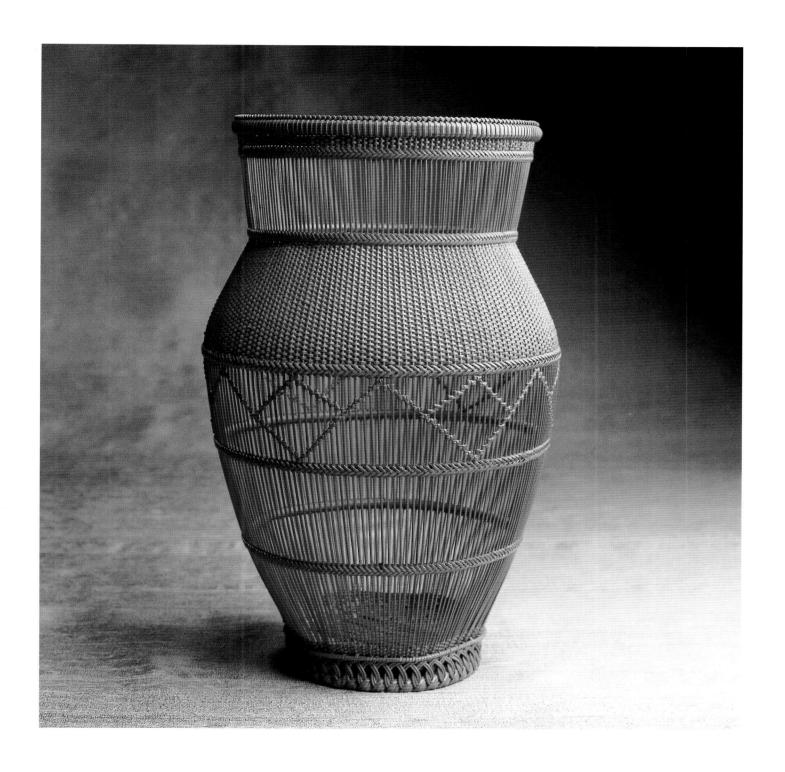

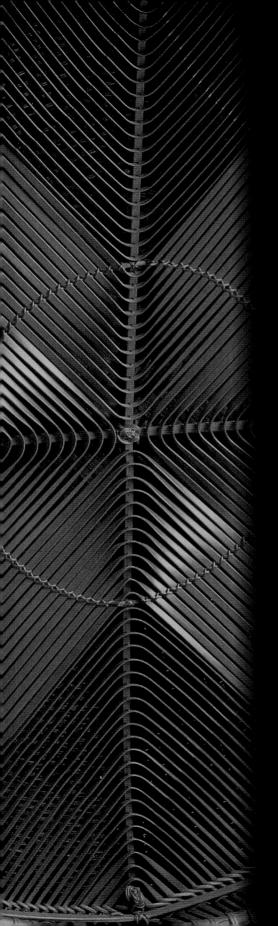

Hayakawa Shōkosai V
born 1932, lives in Kyoto

Hayakawa Shōkosai V was born in Osaka, the first son of Shōkosai IV, a fifth generation bamboo artist. His great-great grandfather, Hayakawa Shokōsai I, was the first bamboo artist to sign his work. Only one son of each generation was allowed to inherit the family tradition, according to a tradition set down by the Shokōsai I. Hayakawa says of this venerable past, "I have constantly asked myself, am I good enough to carry the Shōkosai name?"

Forty-eight years have passed since he decided to follow in the footsteps of his father. In 1951 he began training with his father using the name "Shōha." His first solo exhibition took place in 1965 at Osaka Mitsukoshi. In 1966 he was admitted to the Japan Traditional Craft Arts Exhibition for the first time, and in 1968 he became a full member. Hayakawa received an Encouragement Award at the 23rd Japan Traditional Craft Arts Exhibition in 1968, and in 1977 he succeeded his father as Shōkosai V. Many awards and honors have been bestowed upon him, including receiving the title of Honored Status Holder from the Japan Craft Arts Association in 1991, and recognition in 1992 as an Intangible Cultural Asset of Kyoto, where he lives.

Hayakawa says of his work with bamboo, "Let me tell you the truth. I was not at first fond of this art. I did not consider myself skilled enough. But I could not stand the idea of terminating the artist line of our family. So I made a big decision to learn the tradition right after I graduated from high school. After five or six years of hard training, I made my first bamboo basket. The excitement of creating it was unforgettable. I remember the early days. I had learned many techniques and I thought I was so good. I thought I could make anything I wanted. After experiencing more, I realized that the work is really a reflection of inner self. If you try to over manipulate bamboo to make a shape, the shape becomes unnatural or even breaks by force. I began to realize that just as we have feelings, so does bamboo. It tells you how it likes to be shaped if you listen carefully. I constantly talk to and listen to it now. When I can communicate with the bamboo, the work goes smoothly and a beautiful basket is born."

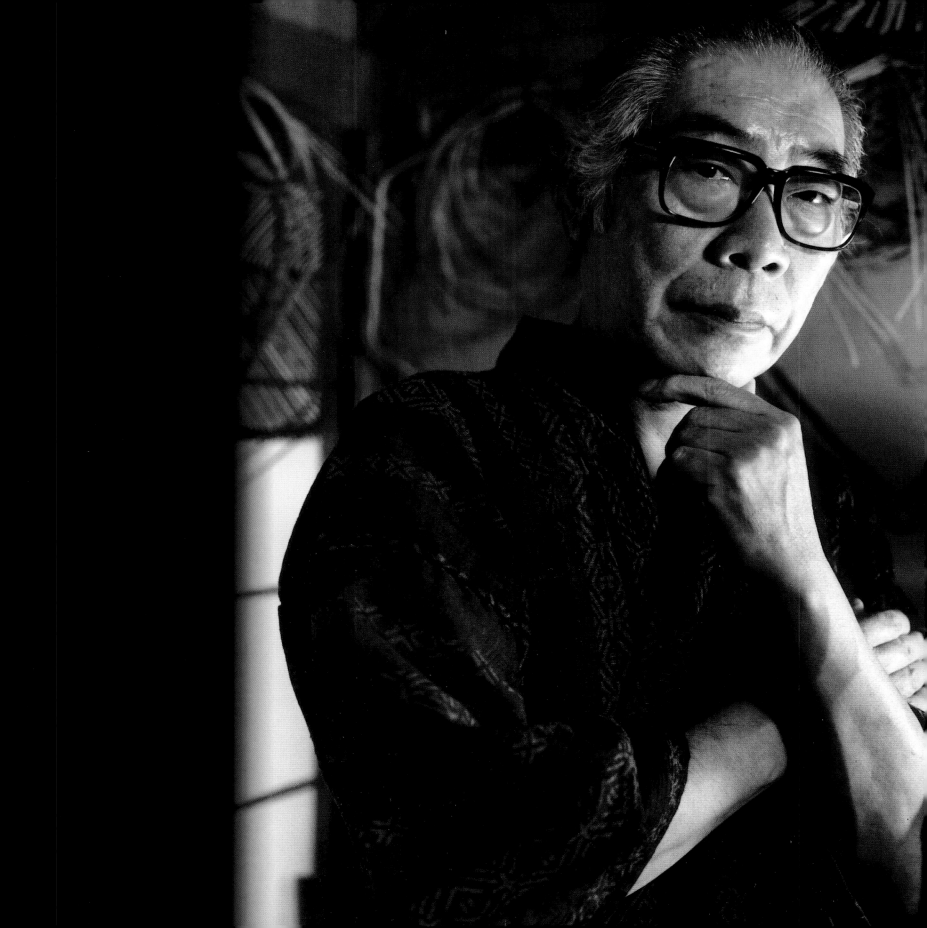

Hayakawa Shōkosai V

UNTITLED, 1994 14″ diameter x 8 1/2″ (36 x 22 cm)

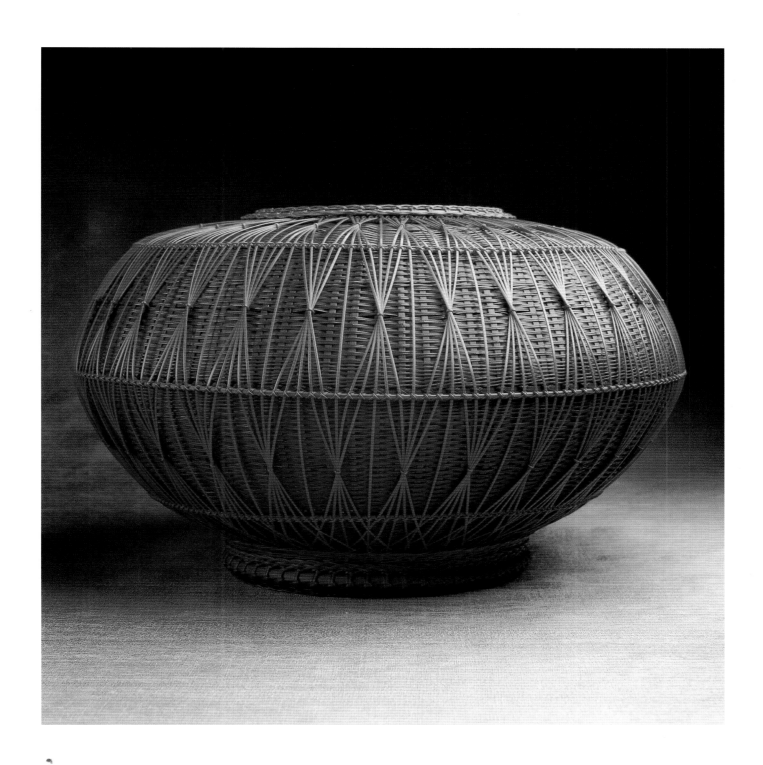

Hayakawa Shōkosai V

UNTITLED, 1996 18 1/2″ diameter x 4 1/2″ (47 x 11 cm)

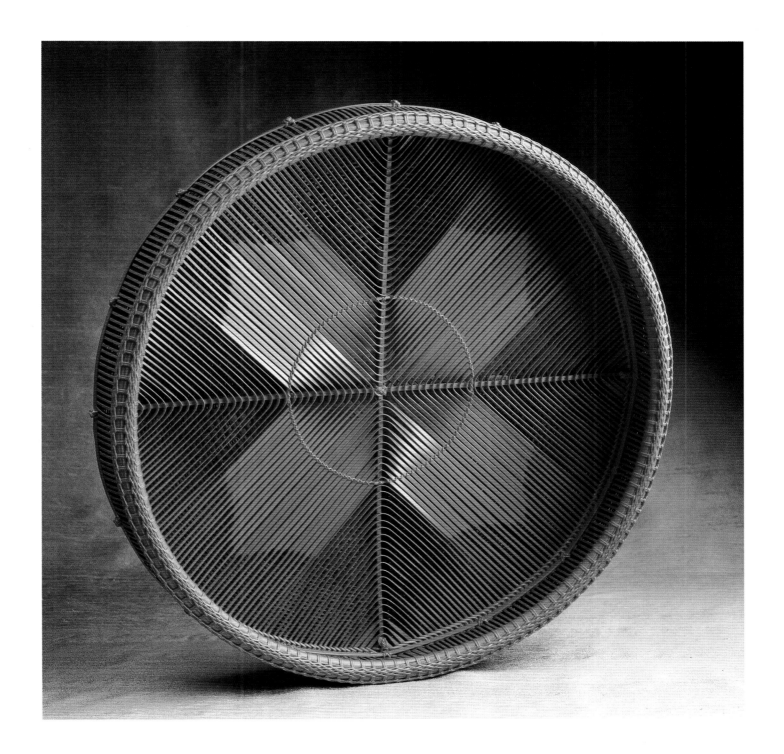

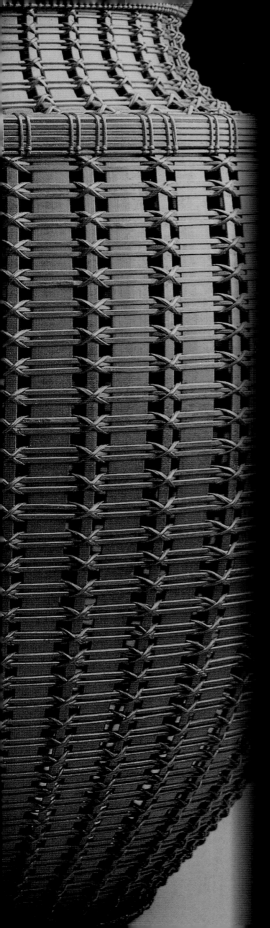

Abe Motoshi
born 1942, lives in Ōita prefecture

Abe Motoshi was born in Beppu, and in 1960 graduated from Midorigaoka High School, Art Division. After finishing high school, he apprenticed for two years with Shōno Shōunsai, the first Living National Treasure of Japan in bamboo arts. In 1963 Abe began helping his father with his bamboo basket business.

In 1967 Abe inherited his father's business. He was admitted to the Japan Traditional Craft Arts Exhibition in 1976 and became a full member in 1980. Since then he has been admitted more than twenty times. He has won numerous prizes, including being a six time winner at the Western Prefecture Craft Exhibition. His works were then purchased by the Beppu City Museum and exhibited at the Tokyo National Museum of Modern Art. By 1998 he had been part of numerous group exhibitions and held solo exhibitions, and was a judge for numerous regional exhibitions.

Abe explains his progress as an artist: "My apprenticeship to master Shōunsai was a very difficult two years. He was so great an artist that I felt I was inferior. I hated myself for not being more artistic. It took me well over ten years to get over those feelings. I realized, after all, I can only be myself. Nothing more, nothing less. I assumed a defiant role toward myself, but of course, not toward my master. My master said to me before passing away in 1974, 'It takes a lot of patience to craft bamboo, so you need a wife with lots of patience.' He said this as he introduced me to the woman who was to become my wife. I owe him a great debt."

Iizuka Shōkansai also had a tremendous influence on Abe, teaching him the importance of mental preparation, which forms the foundation of superior work. "One can never master everything about the art of bamboo," Abe says, "the more you learn, the harder it gets. I struggle every time I work to craft bamboo that reflects my own style of bamboo art."

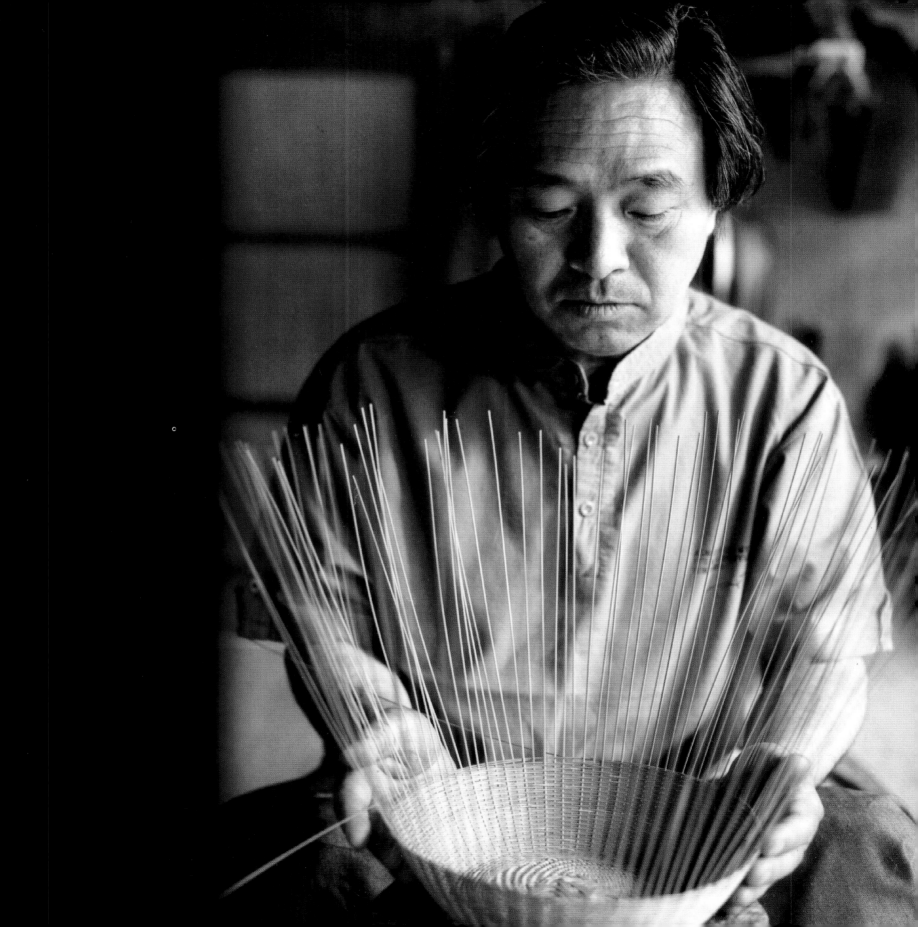

Abe Motoshi

FLOWER PARTY, 1988 16″ x 11 1/2″ x 7 1/2″ (41 x 29 x 19 cm)

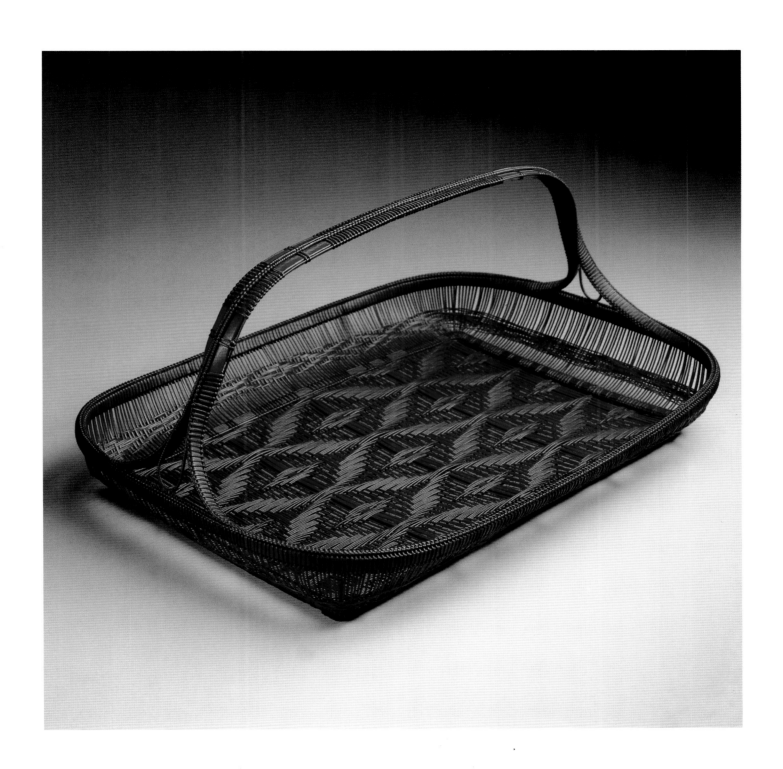

Abe Motoshi

RUGGED MOUNTAIN, 1992 11″ diameter x 11″ (28 x 28 cm)

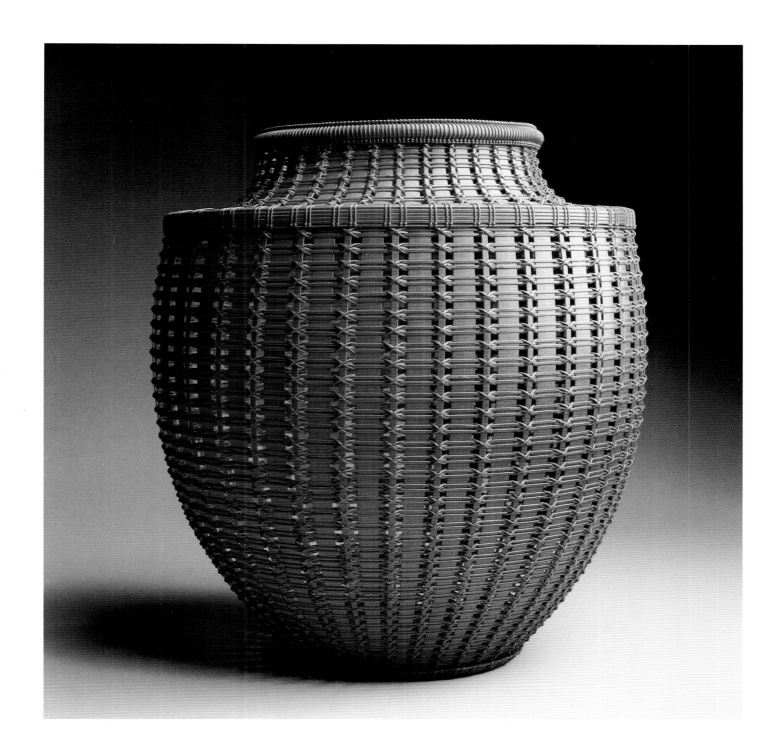

Fujinuma Noboru
born 1945, lives in Tochigi prefecture

Fujinuma Noboru was born north of Tokyo two months before World War II ended. His father was a skilled craftsman. After studying car mechanics and metalwork at Tochigi Technical High School, Fujinuma worked for Nikon managing quality control on metal parts production. He visited Paris in 1974, where he began to reflect on the value of Japanese traditional crafts. Two years later he quit his job and using his savings apprenticed himself to Yagisawa Keizo, a respected bamboo basket maker.

Fujinuma was admitted to the Traditional Craft Arts New Work Exhibition in 1977, and since has been admitted twenty-two times. In 1980 he was admitted to the Japan Traditional Craft Arts Exhibition, subsequently receiving admittance eighteen times, becoming a judge for that exhibition as well as for the Traditional Craft Arts New Works Exhibitions, and the Traditional Craft Arts Wood and Bamboo Exhibitions. He became a full member of the Japan Craft Arts Association in 1984, after his fourth consecutive admittance. Numerous awards followed, including the Tokyo Governor's Award in 1992, and purchase of that winning piece by the National Museum of Modern Art in Tokyo.

Fujinuma has developed a unique color palette that echoes the feeling of smoked bamboo (*susudake*), which comes from the rafters of old farmhouses. This special bamboo is no longer available to younger artists. He admits being torn between craft and art, he respects and adheres to a utilitarian definition for bamboo baskets, yet he maintains that his work is art, adding "I value craft as simple human art. I am most satisfied with a basket when I feel I have succeeded in bringing out the character of the bamboo, and when I can share that moment of intention with someone else." He says that there are two distinct motivations for his work: one type of basket is rustic, bold, and experimental, which he makes for himself; the other type is traditional, more conservative, refined, which he makes to submit to exhibitions. Both directions are valuable to him. He believes in the most important quality of human nature, "honesty," including honesty to oneself and to the craft.

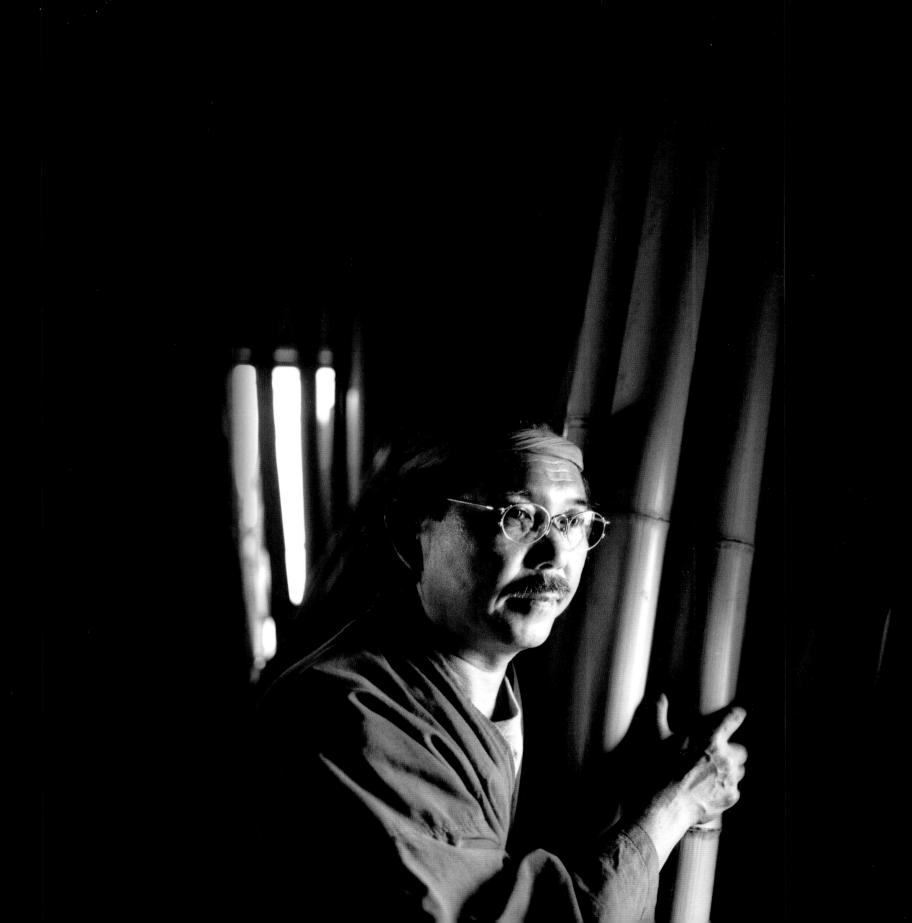

Fujinuma Noboru

PLENTIFUL, 1997 14 1/2″ x 14 1/2″ x 2 1/2″ (37 x 37 x 6 cm)

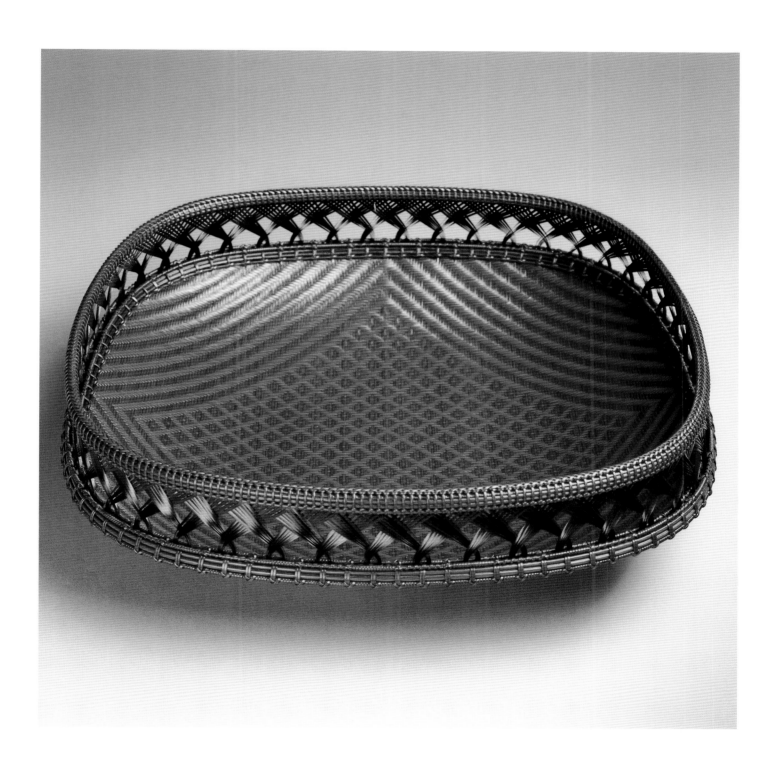

Fujinuma Noboru

SPRING TIDE, 1999 22″ diameter x 15 1/2″ (56 x 39 cm)

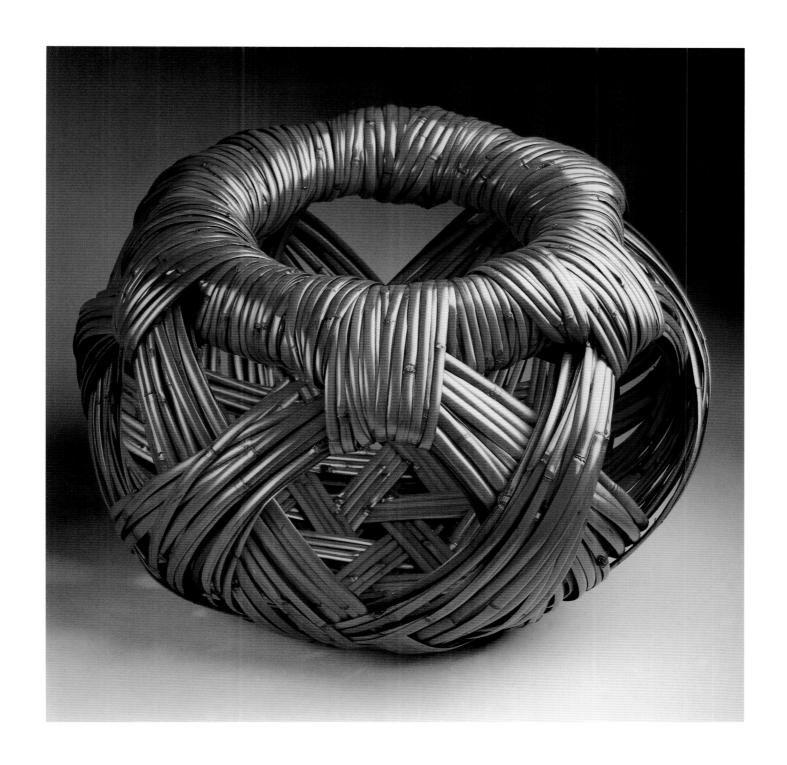

Higashi Takesonosai
born 1915, lives in Kyoto

Higashi Takesonosai was born in Kyoto and began his apprenticeship there with Kaneko Chikukōsai in 1931. He also studied with Wada Rinshisai beginning in 1934. He specialized in basket making exhibiting an architectural flavor. In 1950 he was admitted to Nitten, and since then was admitted twenty-eight times. In 1969 he received a Grand prize at Nitten, thereafter having numerous solo exhibitions in Kyoto and other parts of Japan. In 1990, his work was accepted for exhibition at the Japan Traditional Craft Arts Exhibition, and he became a full member of the Japan Craft Arts Association in 1994. He won the Prince Takamatsu Commemorative Prize in 1995.

Higashi generally uses smoked bamboo (*susudake*) from the rafters of farm houses, often over 150 years old. Incorporating his own new inventions and other non-plaited techniques, he intends to give "wonder and surprise all the time." He says of his art, "A writer uses words to create magic; I use bamboo. My inspiration usually comes from nature. What I am doing is drawing nature with bamboo instead of with a paintbrush. You need to learn everything about bamboo in order to work with it. You need to learn it with all of your senses. Your body needs to know what you are working with. A great work is a combination of artistic beauty and technical excellence, but a masterpiece adds another quality that is a reflection of you as a person. Beautiful work requires a beauty within, thus, your inner self has to be beautiful when you create. My goal as an artist is to leave such pieces when I leave this world."

When asked at the age of eighty-three about his continuing commitment to working in bamboo, he says that as he has grown older, his vision of what he wants to say in his art has become stronger. He adds with a grin that he has a twenty-year supply of smoked bamboo.

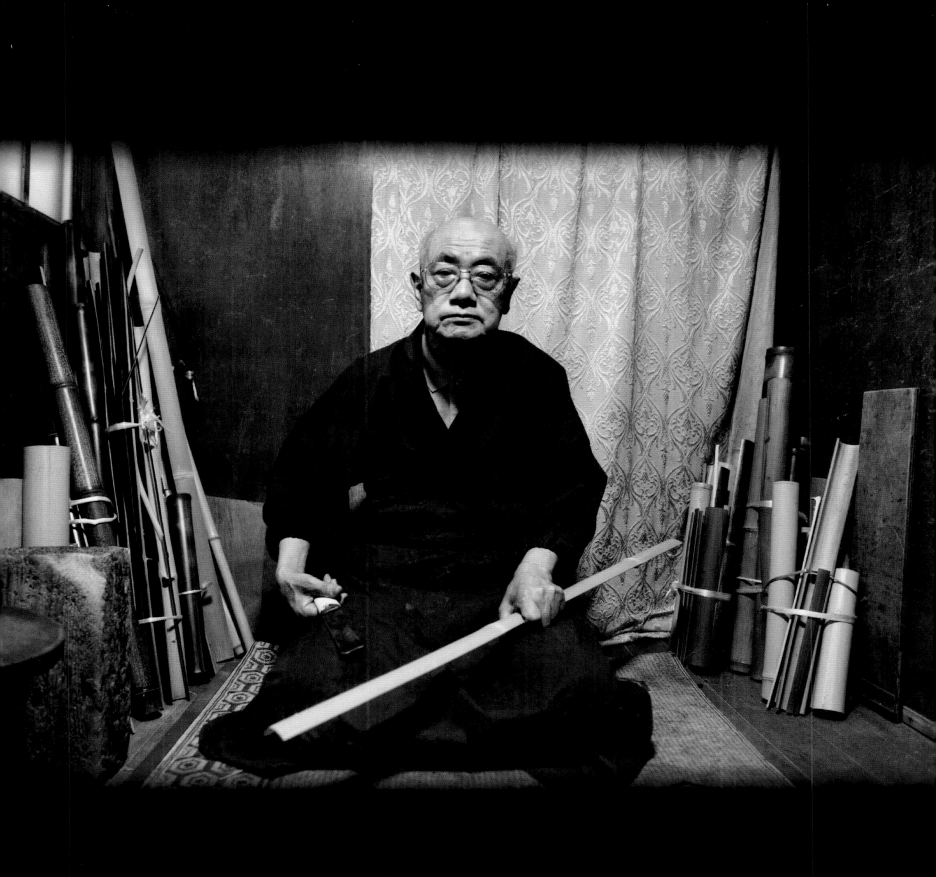

Higashi Takesonosai

SUN, 1984 7 1/2" diameter x 10" (19 x 25 cm)

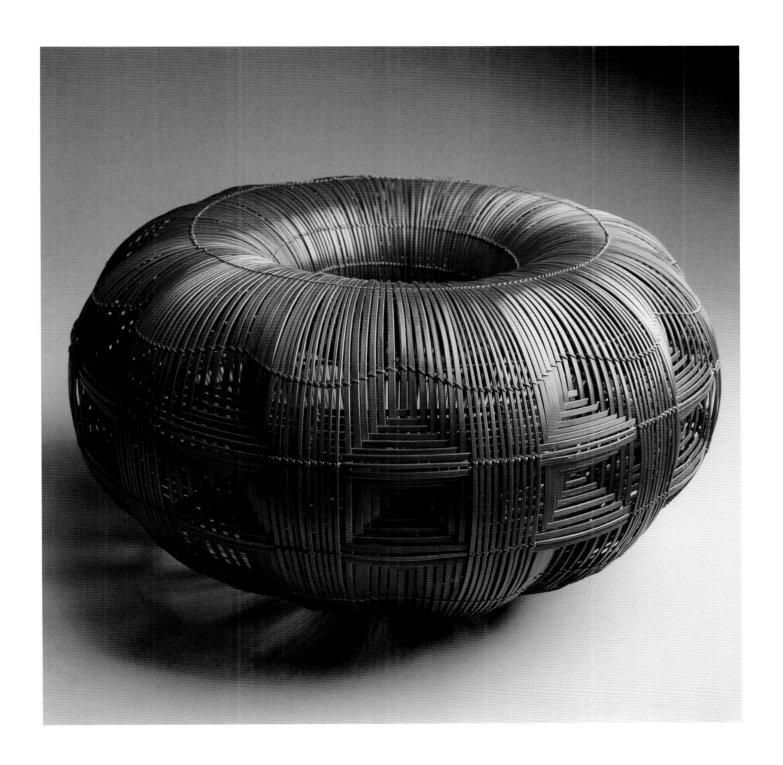

Higashi Takesonosai

PURE STREAM, 1997 22" x 13 1/4" x 2" (56 x 34 x 5 cm)

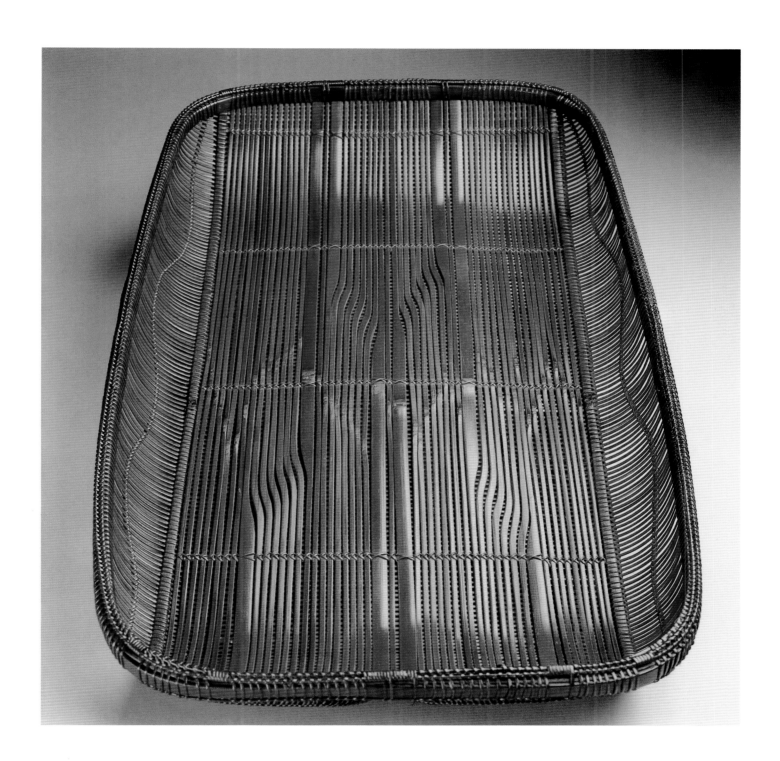

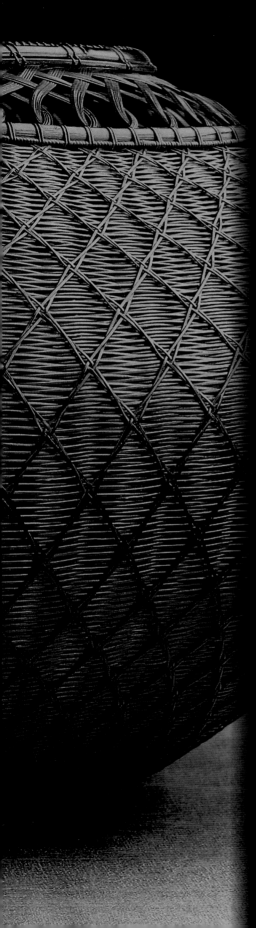

Kajiwara Kōhō
born 1935, lives in Ōita prefecture

Kajiwara Kōhō was born in Kamitsue, a mountain village in Ōita Prefecture. He loved drawing and crafts so much that a family friend, a village doctor, suggested he study bamboo with Iwao Kounsai. He did so in 1952 and apprenticed for ten years. He had initially planned to become independent sooner but an extended illness changed his mind. He had seen that he needed to learn as much as possible from Iwao.

In 1965 he was first admitted to the Beppu City Art Exhibition and since then many times. In 1977 he was admitted to the Seibu Traditional Craft Arts Exhibition, and subsequently many times. He was first admitted into the Japan Traditional Craft Arts Exhibition in 1979, and after that admitted sixteen times. He became a full member of the Japan Craft Arts Association in 1985. In 1986, the Ministry of International Trade and Industry recognized him as a Traditional Craft Arts Skill Holder. Kajiwara won the NHK Chairman's award in 1991 at the Japan Traditional Craft Arts Exhibition. In 1996, his work was presented to the President of France.

He describes his process: "A part of my brain is constantly thinking about the next work no matter what I am doing. When I get an idea, I draw rough sketches on the back of a calendar, and later draw a more detailed plan. I then try to express the natural beauty of Japan through bamboo. Anyone who is talented with their hands can weave and plait bamboo baskets, but to make something fine you must have an impressionable heart. If you are the type of person who does not think anything upon seeing a little flower growing along the street, you should forget about becoming an artist."

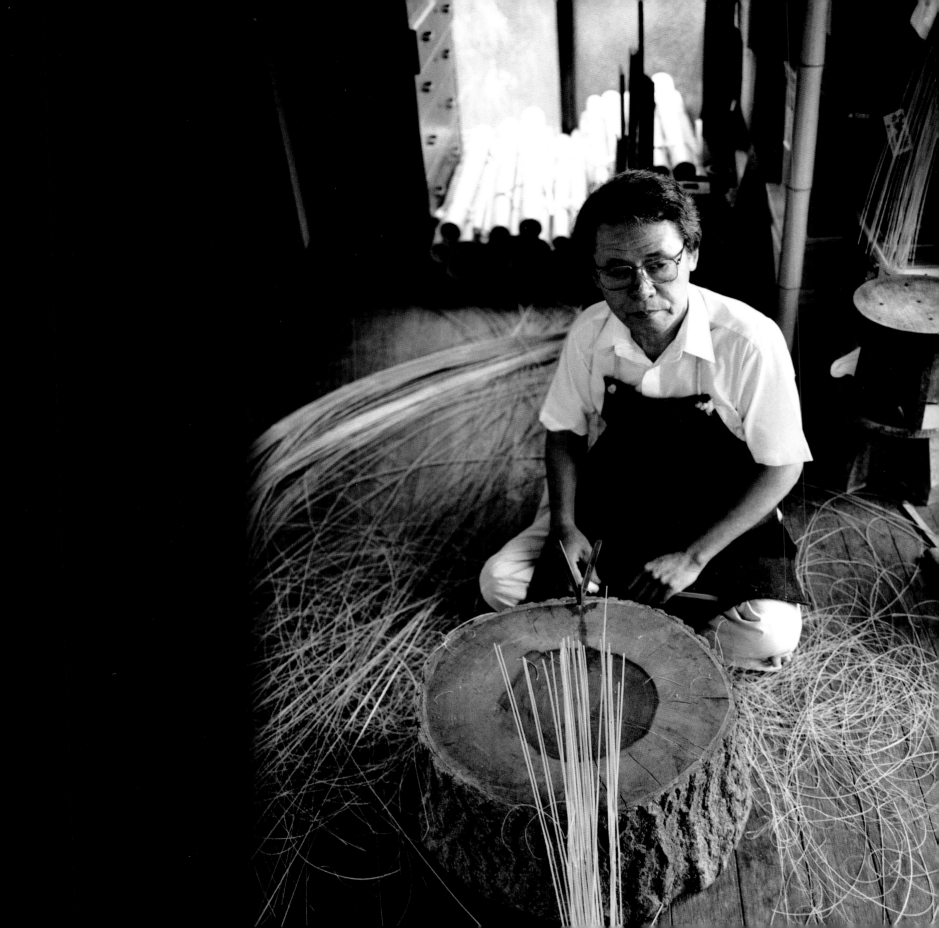

Kajiwara Kōhō

NET, 1986 15″ diameter x 11″ (38 x 28 cm)

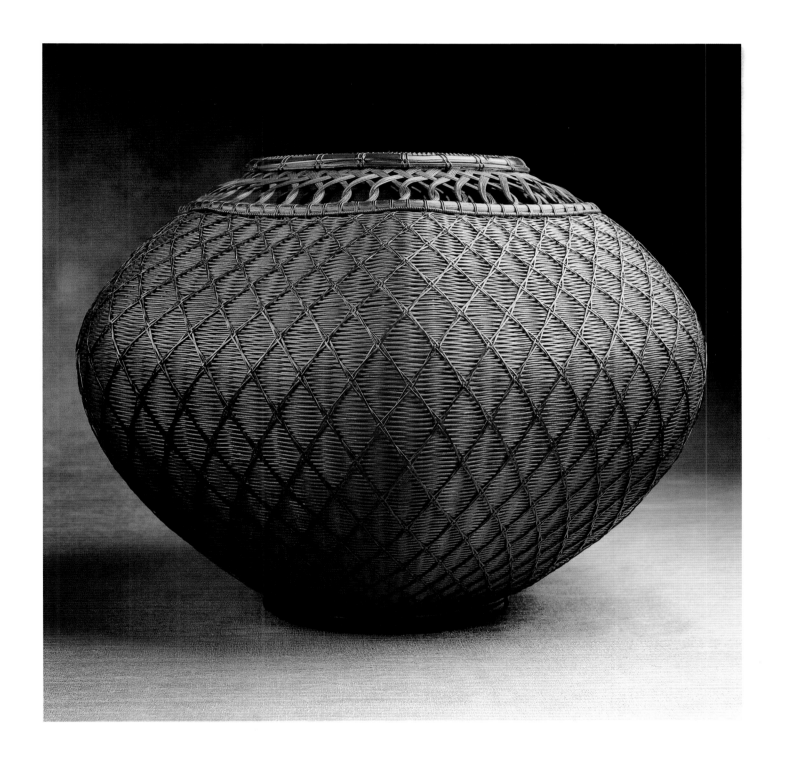

Kajiwara Kōhō

RIPPLE, 1998 16″ diameter x 7″ (41 x 18 cm)

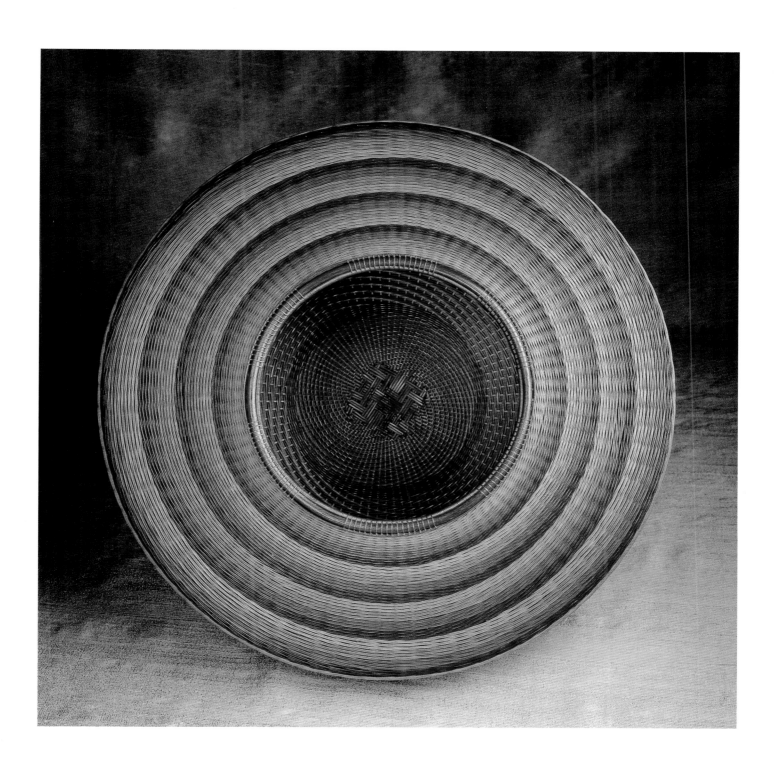

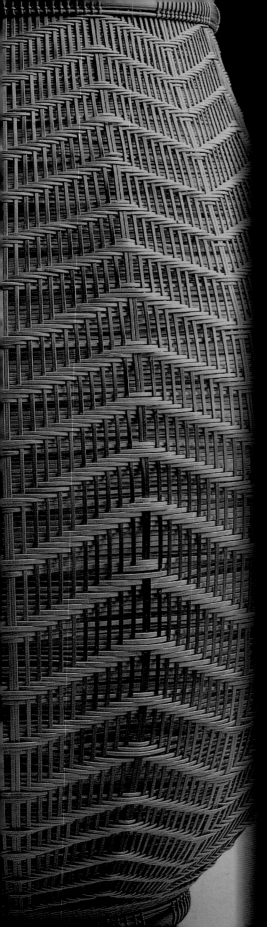

Kajiwara Aya
born 1941, lives in Ōita prefecture

Kajiwara Aya was born in the town of Sagaseki, and graduated from Iwata Women's High School in 1959. She married Kajiwara Kōhō in 1971, and learned to craft bamboo by helping with her husband's work. She gave birth to a daughter in 1972 and a son in 1974. When her daughter entered grade school, Kajiwara entered Beppu Vocational School to learn more about bamboo. She graduated in 1980, and in 1983, encouraged by her teacher Matsuda, she and fifteen other women formed a bamboo craft association that organized exhibitions.

In 1985 she was admitted to the Seibu Traditional Craft Arts Exhibition for the first time and thereafter eleven times. In the same year she won the Beppu Mayor's Award at the 22nd Bamboo Craft Arts New Work Exhibition. Since that time she has been awarded numerous prizes and honors, including the Ōita and Kagoshima Governor's Awards. She was admitted to the Japan Traditional Craft Arts Exhibition six times beginning in 1992. This year she became the first woman bamboo artist to become a full member of the Japan Craft Arts Association.

She describes her commitment to bamboo art: "Many bamboo artists must take part-time jobs, which keeps us from our craft art work. I myself have a part-time job helping at a rest home. You cannot become rich as a bamboo artist, even if your work wins awards of excellence. But you know I love working with bamboo. I am still weaving and plaiting in the middle of the night. To become a bamboo artist, you have to love bamboo. You cannot create that wonderful curved line with any other materials, and the feeling when you have achieved what you imagined is unforgettable."

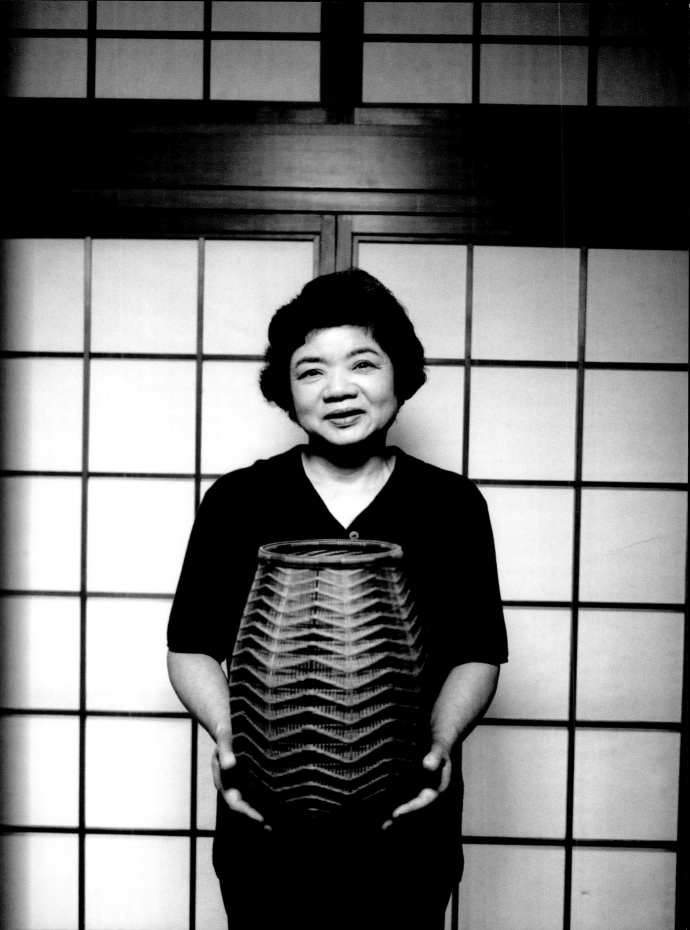

Kajiwara Aya

COLORFUL WAVES, 1997 9" diameter x 14" (23 x 36 cm)

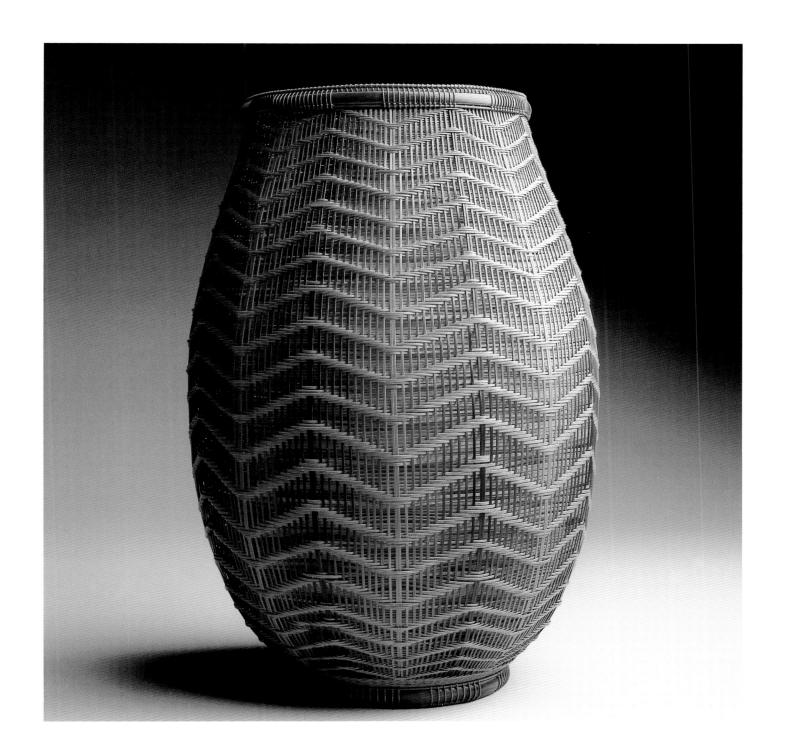

Kajiwara Aya

SHORE, 1995 11″ diameter x 14″ (28 x 36 cm)

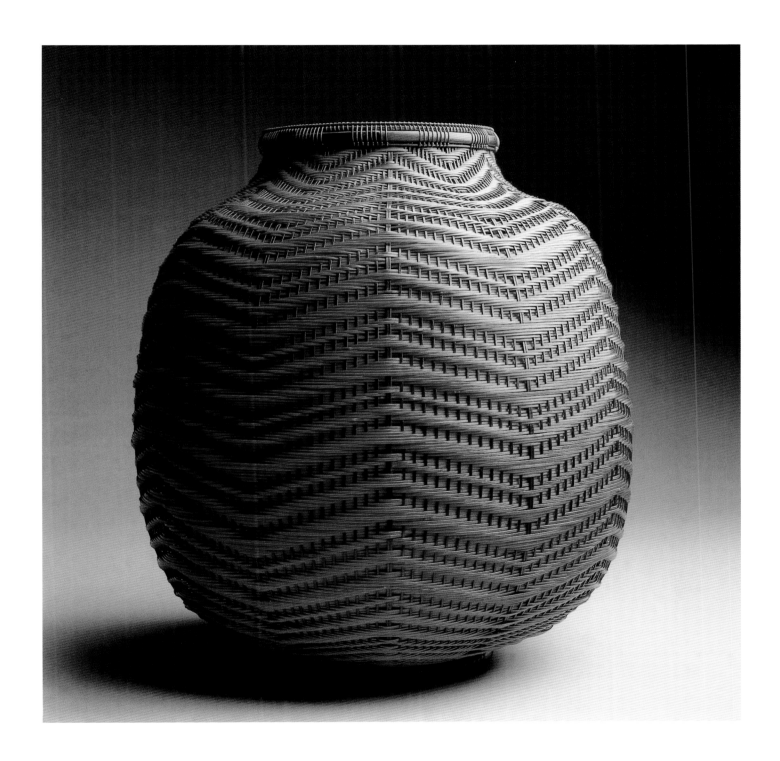

Katsushiro Sōhō
born 1934, Tochigi prefecture

Katsushiro Sōhō was born in the city of Kuroiso. After learning from his father to make utilitarian baskets, he apprenticed in 1949 to bamboo craftsman Kikuchi Yoshii for six years. He became independent in 1955, but then studied again under the renowned bamboo craftsman Yagisawa Keizo for two years, whereupon he was admitted to the Traditional Craft Arts New Works Exhibition for the first time in 1967. He has since been admitted more than thirty times and received the Japan Craft Arts Association Chairman's award.

In 1968 he was admitted to the Japan Traditional Craft Arts Exhibition and has subsequently been exhibited twenty-nine times. That same year he began receiving lessons from Satō Bunseki, who had apprenticed with Iizuka Rōkansai. In 1972 Katsushiro became an official member of the Japan Craft Arts Association. During the next two decades he received numerous prestigious awards, including the Tokyo Governor's Award in 1983, NHK Chairman's Award in 1997, and the Order of Cultural Merit in 1998. He has been a judge numerous times. His work has been purchased by the Tokyo National Museum and elsewhere, and shown internationally.

Katsushiro lives and works on his family farm. He explains his approach to art: "At first I took ideas from other baskets that I liked. Then I began to get inspired by nature. I have a friend who is a painter. He paints in the field. I wondered if I might capture that spontaneous feel of nature in my baskets. Because I am a farmer, I understand the 'smell' of nature. I have a keen sense of the seasons. Observing nature I obtain new themes for my baskets. The themes I choose are usually bright and joyful. The beauty of bamboo, to me, is the way it reveals a dynamic line in space. I honor traditional techniques, but I think the development of new techniques is also very important."

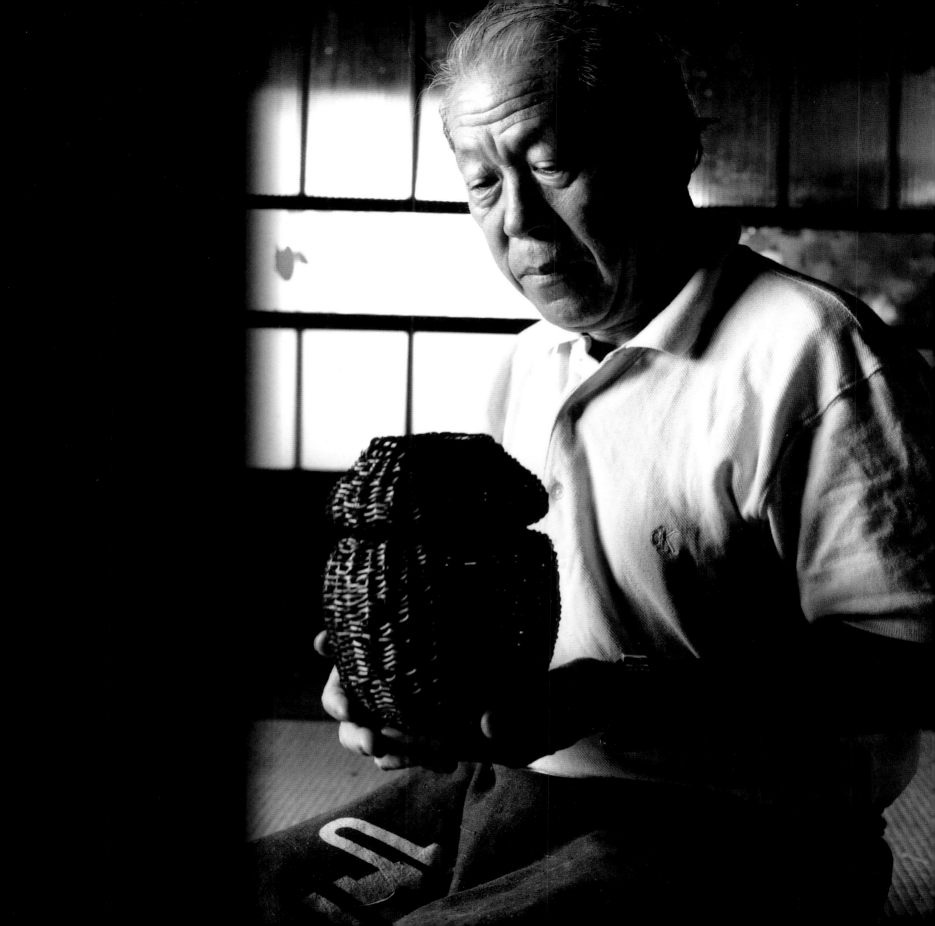

Katsushiro Sōhō

RAIN, 1998 12" x 14 1/4" x 6" (31 x 37 x 15 cm)

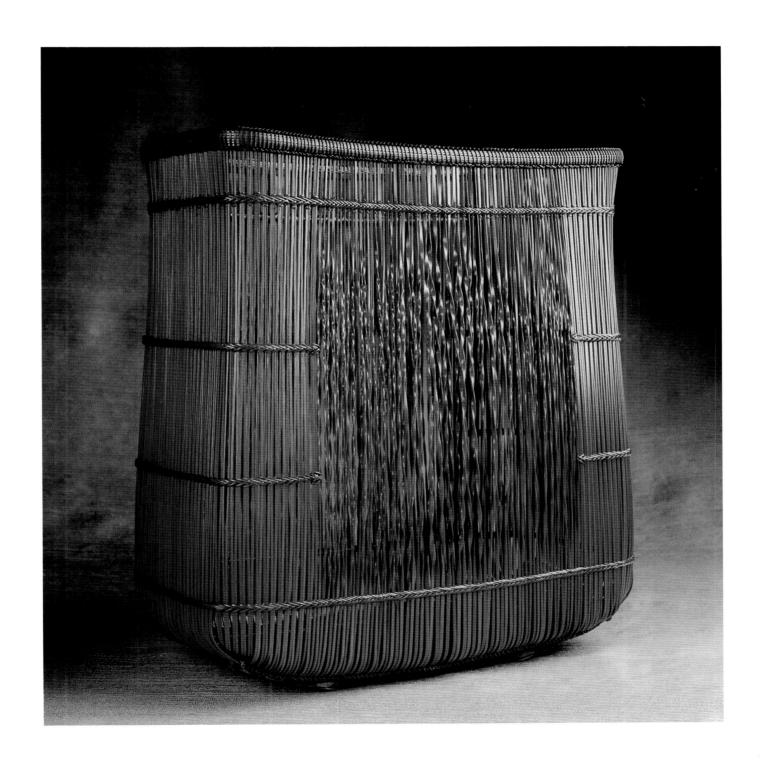

Katsushiro Sōhō

TURNED EARTH, 1999 23 1/2″ x 14″ x 10″ (60 x 36 x 25 cm)

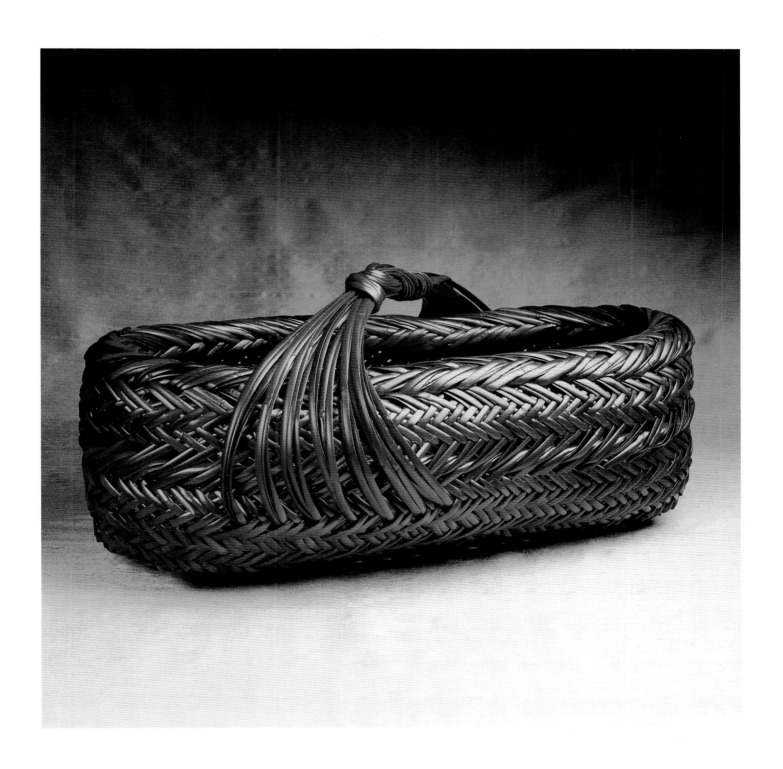

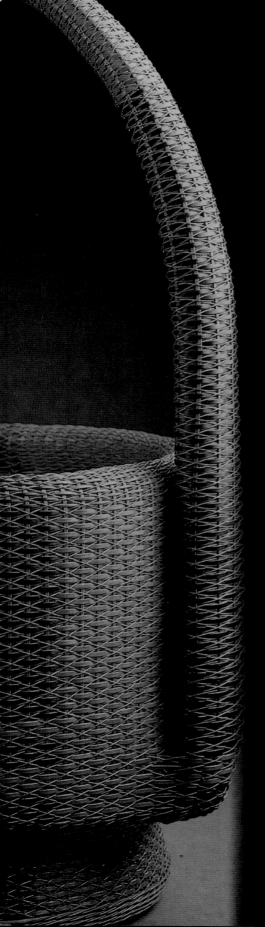

Monden Kyōgoku
born 1916, lives in Hiroshima prefecture

Monden Kyōgoku was born in Hiroshima and moved to Beppu as a teenager for health reason. There he became in interested in bamboo basket making and in 1933 became an apprentice to Kadota Nikō. By 1935, he was winner of the Governor's Award at Ōita Prefecture Art Exhibition, and went on to win the award three times consecutively. In 1937 he was admitted to the National Craft Arts Exhibition. He was given the artistic name of Kyōgoku, which means bamboo grove treasure. His career as an artist was disrupted by the war and the economic turmoil following. During this period, he employed several workers and they made thousands of utilitarian baskets for sale to wholesalers. This period of his life came to an end when a local department store manager having heard about his earlier career as a bamboo artist asked him to do an exhibition of flower baskets.

He was admitted to Nitten in 1973 and exhibited eight more times. Monden also exhibited in the Modern Craft Arts Exhibition and the New Craft Arts Exhibition. He has won various awards including the Okayama Prefecture Governor's Award at the Modern Crafts Artists Association Prefectural Exhibition in 1974 and the Japan New Craft Arts Award at the New Craft Arts Exhibition in 1979.

Subsequently he won numerous awards in prefectural exhibitions, and he became a judge of the Hiroshima Prefectural Art Exhibition in 1986. In 1987 he was admitted to the Japan Traditional Craft Arts Exhibition and thereafter eleven times. He became a full member in 1991. He is very active as a leader in his prefecture, as a judge for exhibitions, as well as teaching at the community college in Fukuyama City, and officiating at various regional competitions.

Monden tells his students: "Don't imitate others, create your own personal style. And don't be afraid of making mistakes. Even if it's bad, you will gain something in your efforts."

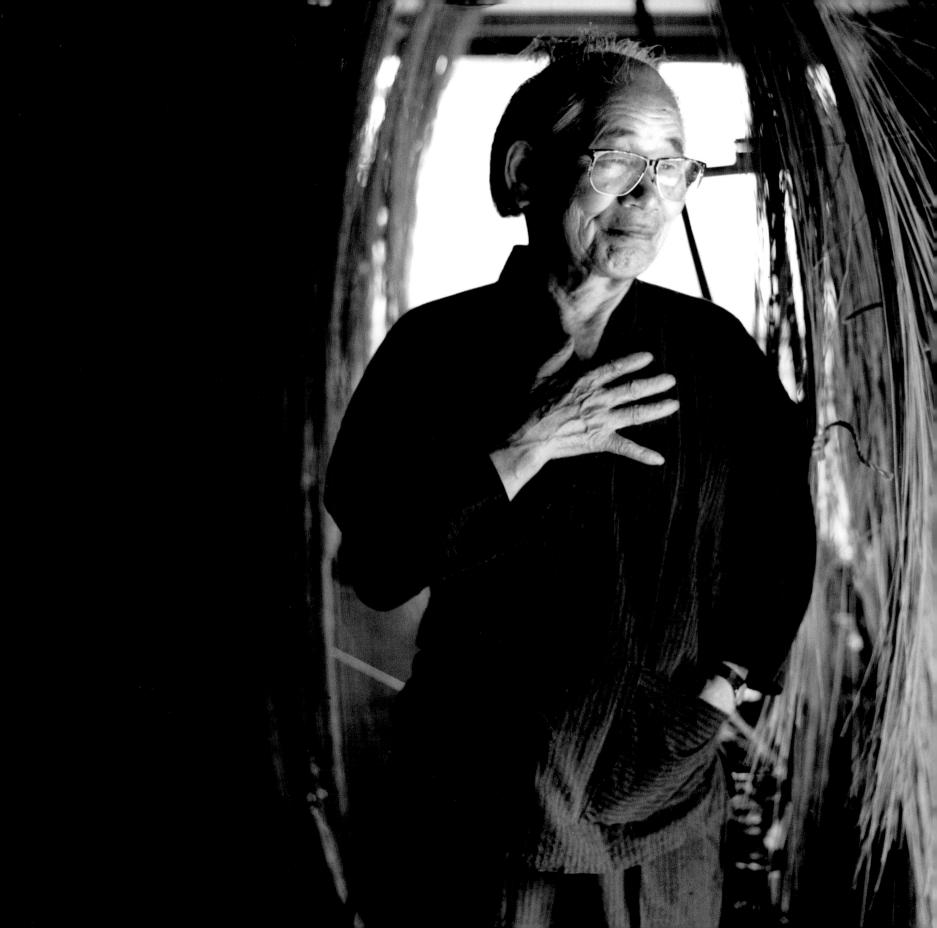

Monden Kyōgoku

FLOWER OF WAVES, 1977 21″ diameter x 17″ (53 x 43 cm)

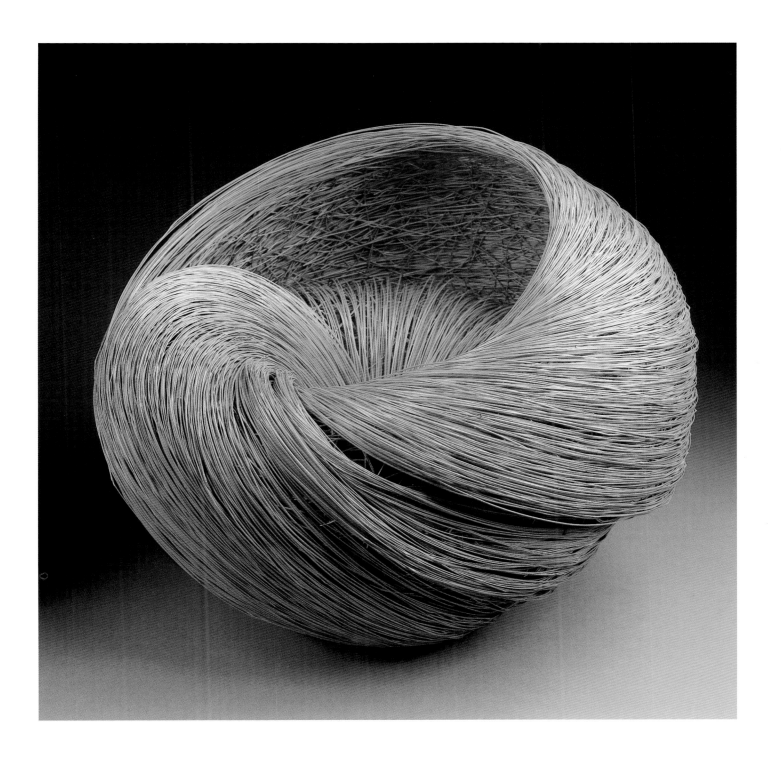

Monden Kyōgoku

UNTITLED, 1979 11" diameter x 18" (28 x 46 cm)

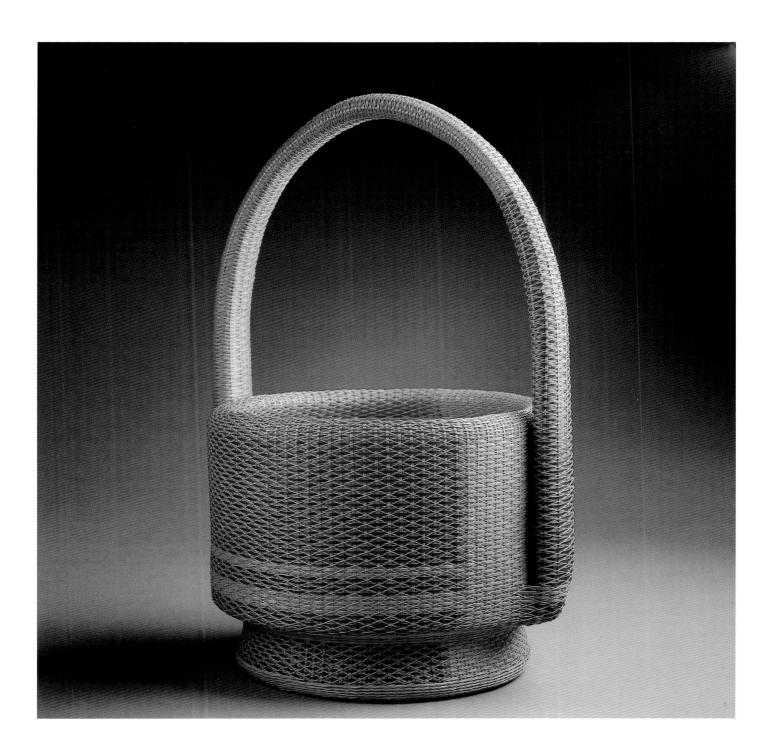

Tanioka Shigeo
born 1949, lives in Osaka

Tanioka Shigeo was born in Hyōgo prefecture, and after graduating from design school worked at an advertising company for two years. He was not happy there, and one day while reading a book found a photograph of one of Shōno Shōunsai's most famous baskets. He decided then to study bamboo art, and at the age of twenty-five apprenticed himself to Tanabe Chikuunsai II, and by 1984 he had become an independent bamboo artist. In 1987 he was admitted to the Japan Traditional Craft Arts Exhibition, and thereafter was admitted five times. He has won prizes including the Grand Prize at the Osaka Prefecture Craft Arts Exhibition, the Chief of Cultural Office Award at the Traditional Wood and Bamboo Craft Arts Exhibition and Kinki Regional Award at the Kinki Traditional Craft Arts Exhibition. He became a full member of the Japan Craft Arts Association in 1997.

Tanioka says of his work, "You must keep the first inspiration of how you became interested in this art. You must never be fully satisfied with your work, so you can always have a challenging spirit to create something new. Bamboo is most beautiful and perfect when it is in nature. We break this perfection to give another life to bamboo.

"It is a question whether bamboo craft art is a concrete expression or an abstract expression. It is hard to give bamboo art a concrete expression, therefore, I think most of the bamboo arts are an abstraction in form. In addition, you can give verbal explanations to your work to show how you as an artist wanted to make a statement, like some 'avant-garde artists' might do. I think, however, that the goal of bamboo artists is to show how well you can reconstruct the natural beauty of bamboo through your creativity, originality, and techniques of weaving and plating. To make a piece for exhibition takes months of work. Probably the best analogy I can use to describe this process is climbing a mountain. It is a long and hard process. When you are finally on top of the mountain, you feel the moment of satisfaction. Yet this satisfaction won't last long."

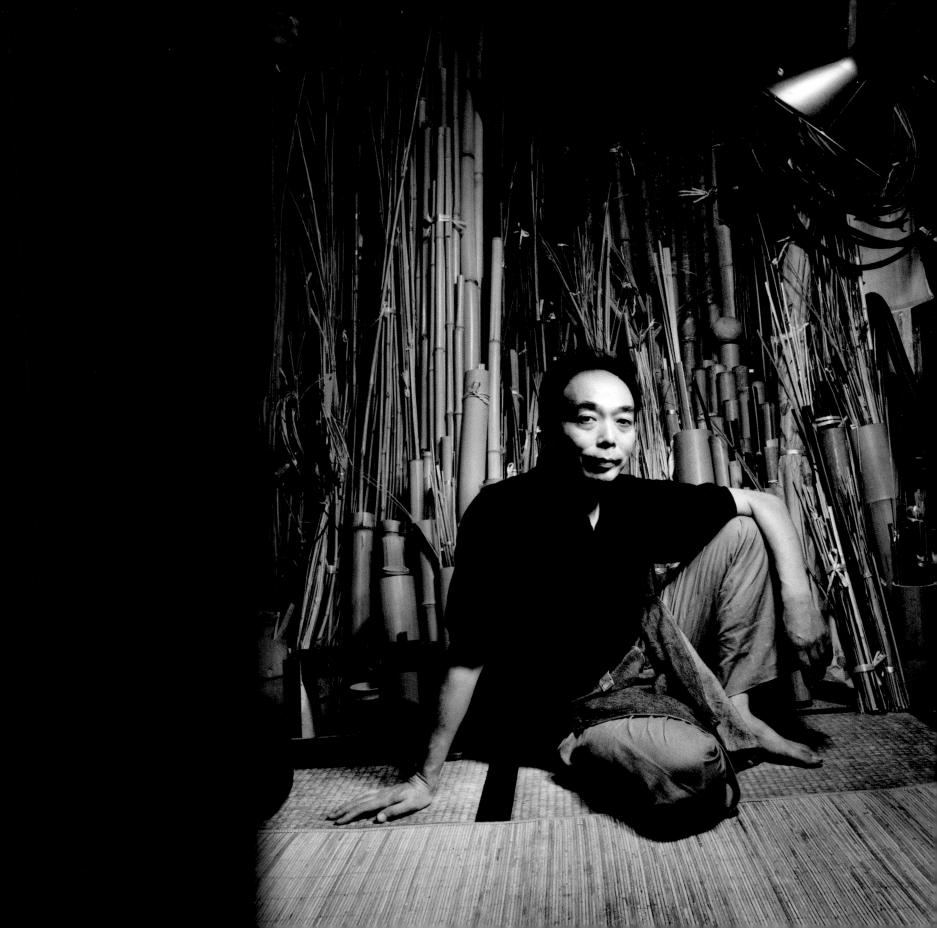

Tanioka Shigeo

FOUNTAIN, 1993 17" x 11" x 6" (43 x 28 x 15 cm)

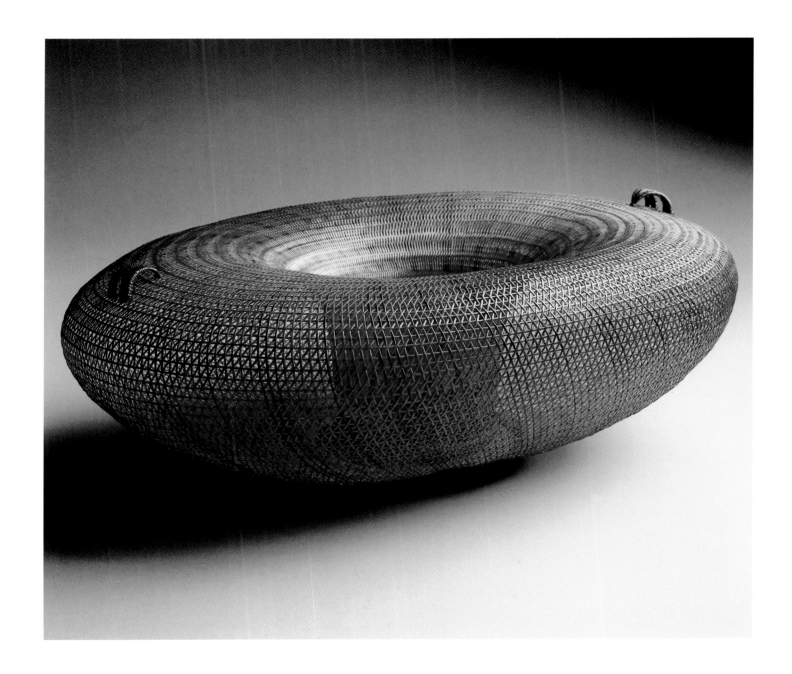

Tanioka Shigeo

MAJESTIC LAND, 1999 31" x 11" x 8" (79 x 28 x 20 cm)

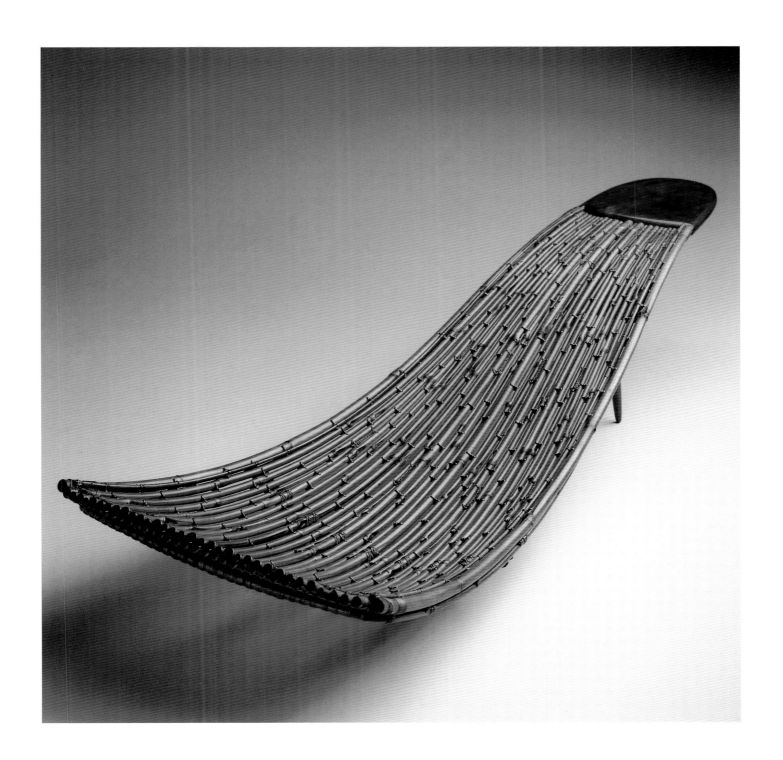

Watanabe Shōchikusai II
born 1927, lives in Ōita prefecture

Watanabe Shōchikusai II was born in Toyama as the youngest child of three. His father, a teacher, died in 1935 of tuberculosis, and two years later his mother came down with the same illness and she too died. His paternal uncle took charge of the orphaned children.

The uncle often went to Beppu for vacations, a popular hot springs retreat and bamboo growing region. He brought back many bamboo flower baskets. In 1941, Watanabe graduated from high school and was sent to Beppu to learn bamboo craft under the guidance of Kadota Nikō. There, he was introduced to Watanabe Shōchikusai I, famous for his "twill plaiting boxes" and became his apprentice. His teacher taught him that "one should have a signature work that others won't do."

After the war, Watanabe married and worked with Watanabe Shōchikusai I. He was then adopted into the Watanabe family upon the death of his master's only daughter, and succeeded the artist's name in 1973. In 1977 he was admitted to the Seibu Traditional Craft Arts Exhibition for the first time. In 1980, the Ministry of International Trade and Industry recognized him as a Traditional Craft Arts Skill Holder. In 1981 he was admitted to the Japan Traditional Craft Arts Exhibition for the first of ten times. That same year the Mikasa family of the Imperial Family purchased his work. He won the NHK Chairman's Award in 1982, and became an official member of the Japan Craft Arts Association upon winning this prize. He received a Governor's Award from Ōita Prefecture in 1995 and the Minister of Commerce Award in 1998.

From his studio in Ōita prefecture, Watanabe says of his work, "Quite honestly, I consider myself an artisan. I only work in twill plaiting, but within this limitation I always push myself to a new innovation. Beauty to me is not static, it is dynamic. Bamboo has certain advantages, such as the capacity to be split so finely that it is suitable for expressing grace and refined elegance. Thinking of patterns, color coordination, and proportions all the time keeps my mind young and flexible. I am happy when I succeed in a new innovation, but I am happier if people like the work and value it."

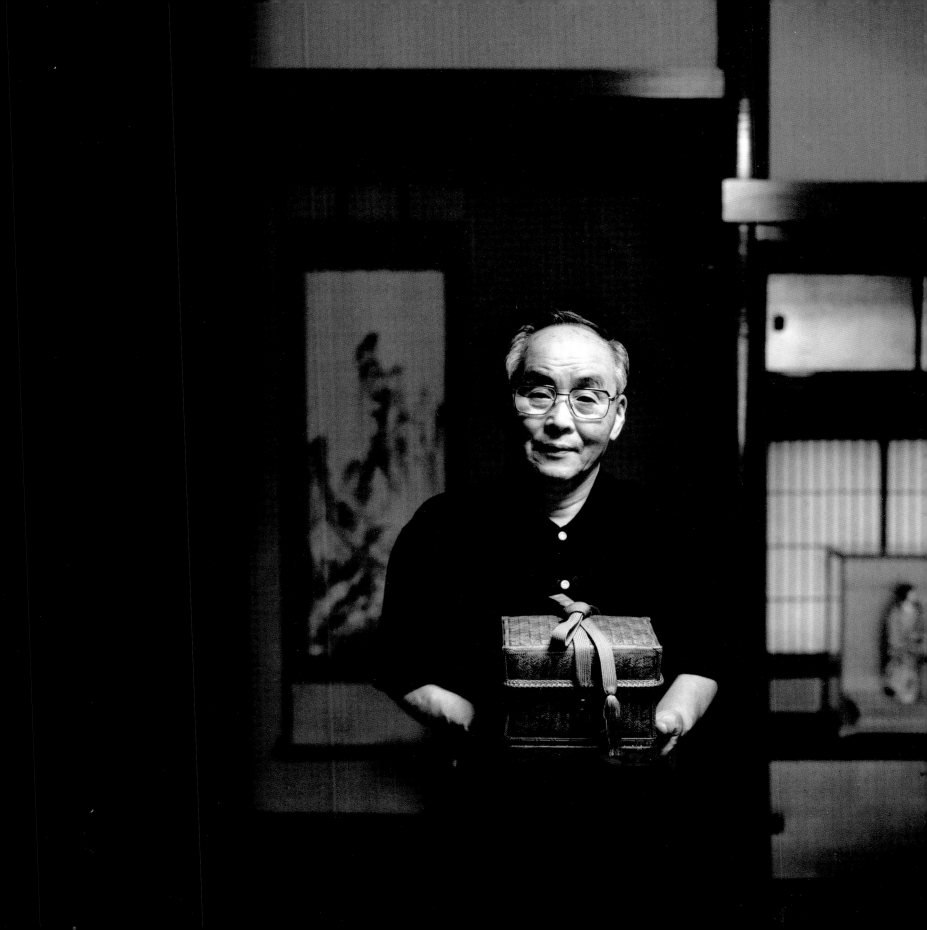

Watanabe Shōchikusai II

UNTITLED, 1994 8″ x 6″ x 6″ (20 x 15 x 15 cm)

Silk ties for the tea ceremony box (*Chabacho*) were by Kinoshita Risa

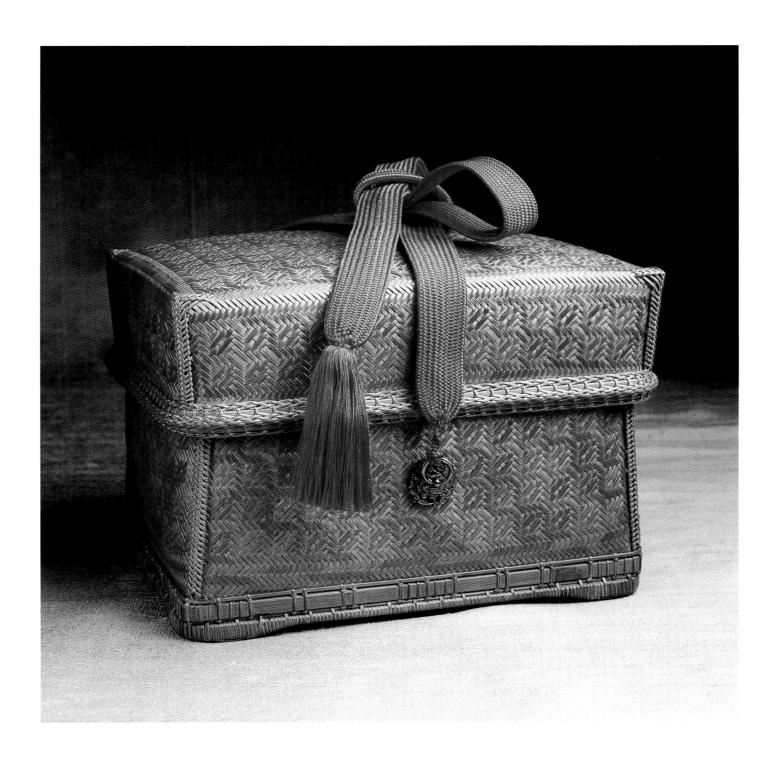

Watanabe Shōchikusai II

UNTITLED, 1996 13 1/4" x 10 1/2" x 3 1/2" (34 x 27 x 9 cm)

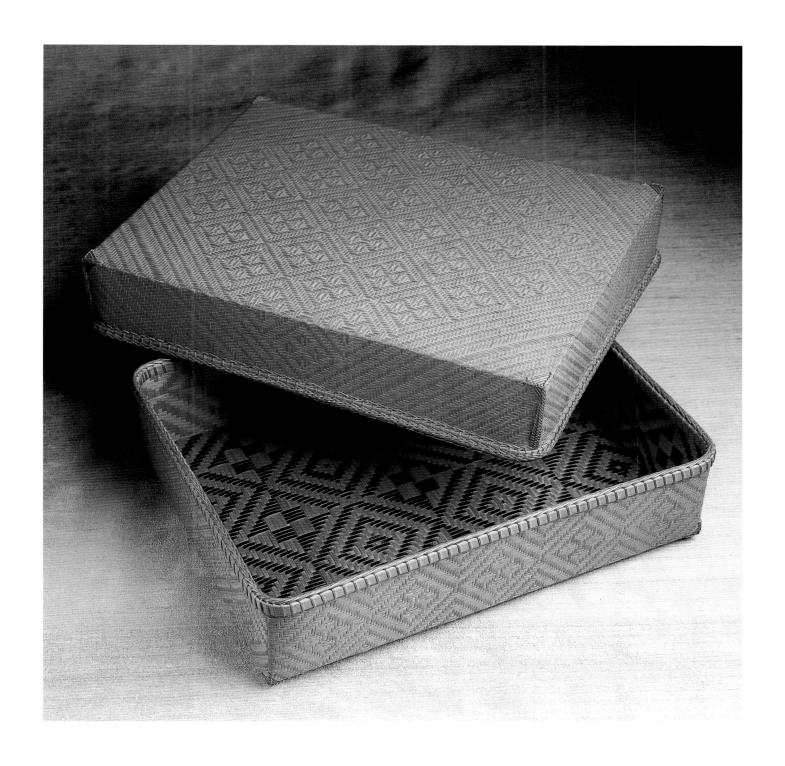

Yako Hodō

born 1940, lives in Saitama prefecture

Yako Hodō was born in Niigata and in 1956, after completing vocational school where he learned the basics of working with bamboo, he was apprenticed at the age of sixteen to master basket maker Nakajima Hōsō for four years. He moved to Tokyo in 1964 and spent a year studying with Nakamura Yukosai and another year with Baba Shōdō.

By 1968 he had won the Tokyo Governor's Award at the Japan Industrial Craft Arts Exhibition. In 1973 he was admitted to Nitten for the first of three times. In the same year he moved to Saitama prefecture to become an independent artist. He crafted thousands of lampshades for years to make a living and continued to create one or two exhibition pieces a year. In 1978 he was admitted to the Modern Craft Arts Exhibition and became a member of the association. He became a judge of the Saitama Prefectural Exhibition, and he won the Saitama Prefecture Governor's Award in 1979. Group and private exhibitions followed. In 1995, he was admitted to the Japan Traditional Craft Arts Exhibition for the first time. The same year he won the Exceptional Technique Award from the Ministry of Labor. This year he became a full member of the Japan Craft Arts Association.

Yako explains his approach to working with bamboo: "When I make a basket, I draw rough sketches first to conceptualize the image I would like to capture. When I get a concrete vision of what I would like to make, I start to prepare the bamboo necessary to complete the piece. This preparation takes as much or more time than actual weaving time. Sometimes I have to make adjustments in the middle of weaving. When I have a hard time finding out what adjustments to make, I try listening to the bamboo and asking it what I should do. It is important to improve one's skills and techniques, but mental preparation and conceptualization are just as important. To see as many works of beauty as possible in order to nurture one's artistic sense is also important. The baskets I make reflect both function and dream."

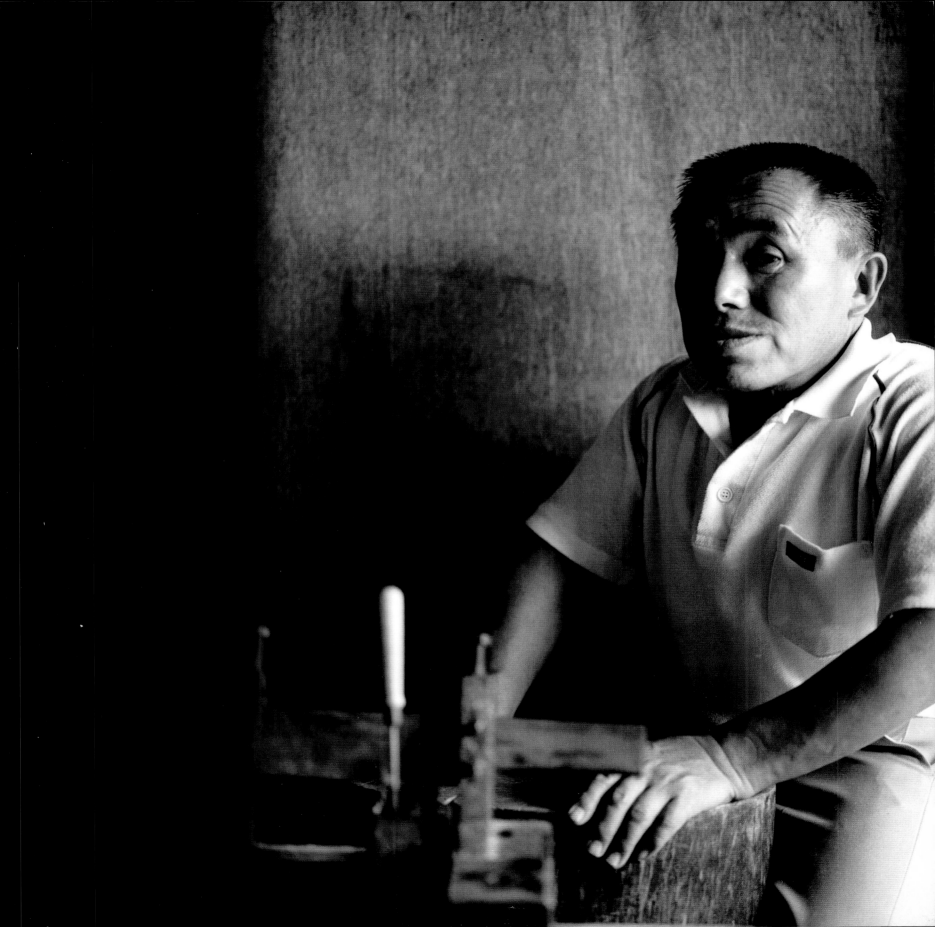

Yako Hodō

AUTUMN SCENE, 1998 10 1/2″ x 4 1/2″ x 16″ (27 x 11 x 41 cm)

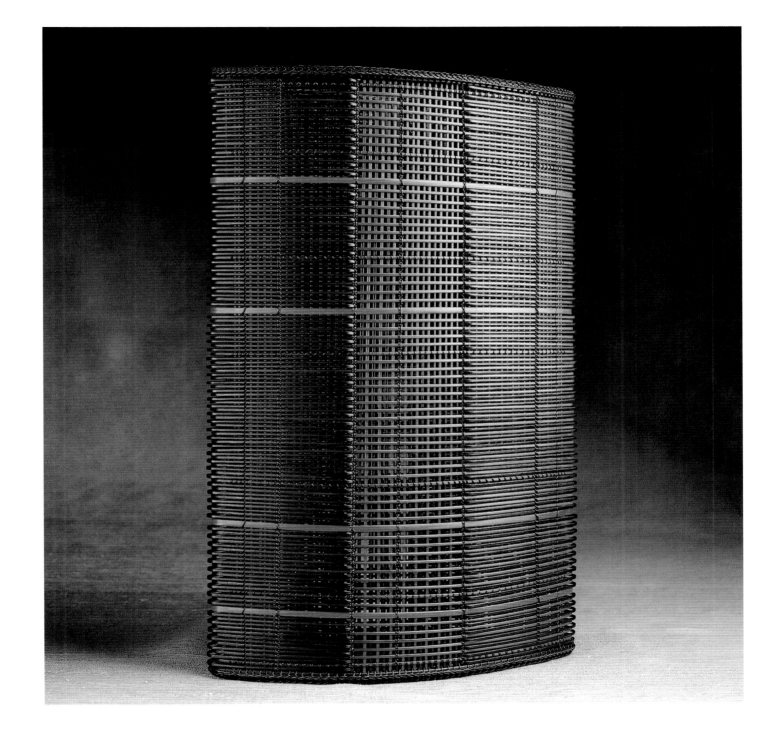

Yako Hodō

SKYSCRAPER, 1985 12 1/2″ x 7″ x 30″ (32 x 18 x 76 cm)

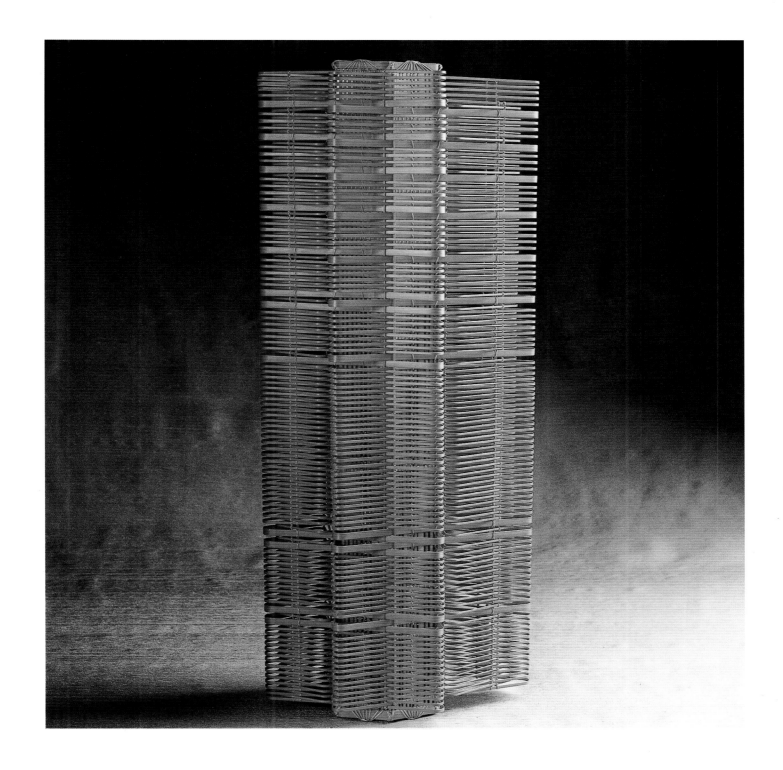

Artists of the Nitten World

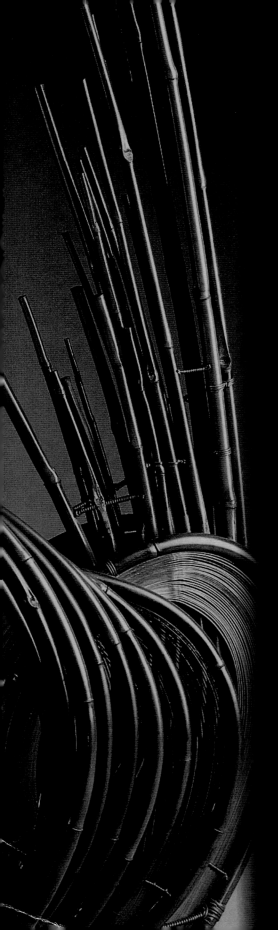

Honma Kazuaki
born 1930, lives in Niigata prefecture

Honma Kazuaki was born on Sado Island and at the age of twenty-two apprenticed himself to Hayashi Shogetsusai, a prominent basket maker. He had seen a brooch made of bamboo at Hayashi's shop, and fell in love with the idea of producing such jewelry. The following year, 1953, he received an encouragement award at the Niigata Prefecture Cultural Festival of Art Exhibition for a bamboo tray. In the same year his health failed and he had to make changes in his life. This led him into starting a business making bamboo brooches. "Bamboo jewelry is made of dozens of bamboo strips woven and knotted rhythmically to express abstract images or shapes from nature," Honma explains. "I made bamboo jewelry in many forms: beetles, cicadas, dragonflies, snails, doves, crested ibis, squirrels, turtles, crabs, shrimps, and angelfish. Even though it was small work, it was fulfilling to create something beautiful. What I made lovingly decorated many ladies. One day I saw a lady in the crowded Osaka train station wearing one of the first brooches I'd made. I was so happy I almost couldn't resist to talking to her."

In 1965 he again began making pieces for exhibition and he was admitted to the Japan Modern Craft Arts Exhibition for the first time, and since has been admitted nine times. In 1977 his work was admitted to Nitten and he won a Grand Prize. He was made a screening member at various regional and specialized exhibitions, and beginning in 1979 held numerous solo exhibitions of his work. He won a second Grand Prize at Nitten in 1983. He became director of the Modern Craft Artists Association in 1986. In 1988 he became a full member of Nitten, and a judge at Nitten for the first time in 1989. In 1992 he published a book, *The Shapes in Bamboo by Honma Kazuaki* to commemorate his having been a bamboo artist for forty years.

Honma says of his work, "I made more traditional flower baskets, but for me traditional basket weaving felt restricted. I wanted to express my thought more freely, so I sought other forms. I found an ideal material in a round sooted bamboo (*hobichiku*). With it, I can make the beautiful curved sculptures that fill my heart with satisfaction and happiness."

Honma Kazuaki

SOUND OF THE WAVE, 1970 24″ x 19 1/2″ x 13 1/2″ (61 x 50 x 34 cm)

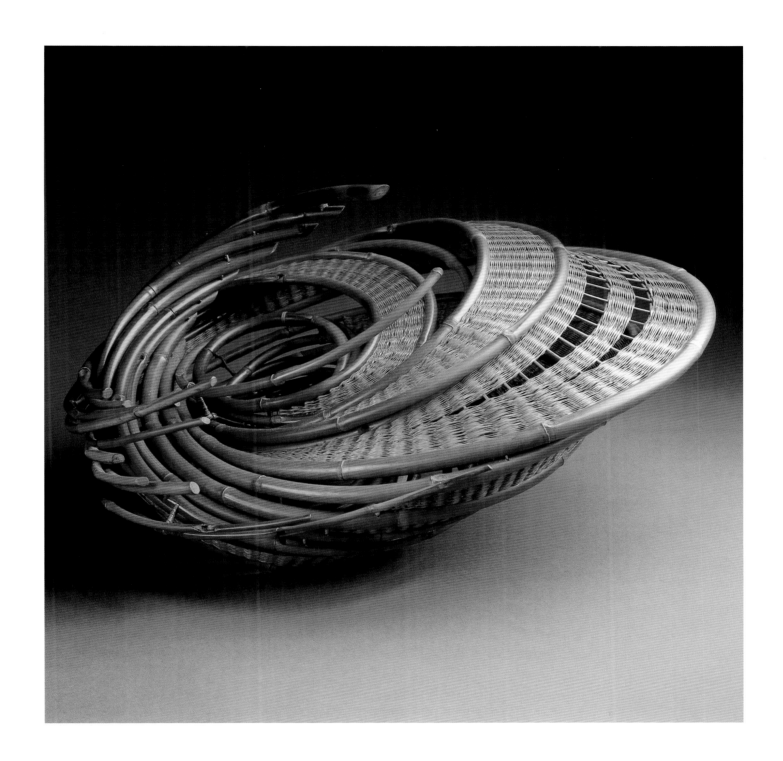

Honma Kazuaki

BREATH, 1968 24″ x 12″ x 35″ (61 x 31 x 89 cm)

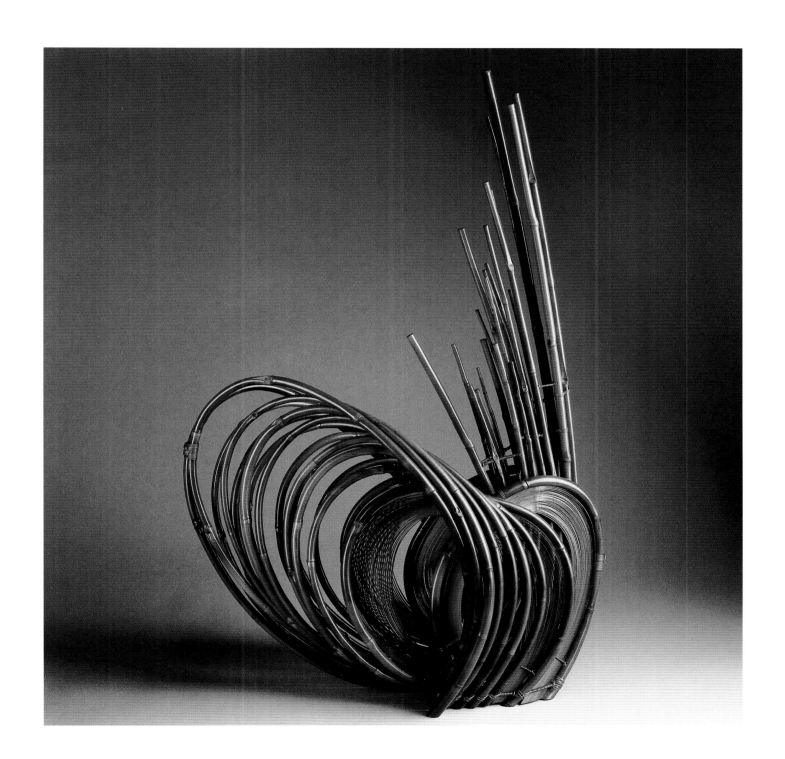

Minoura Chikuho

born 1934, lives in Hyōgo prefecture

Minoura Chikuho was born in Tokyo, and in 1950, at the age of sixteen, he studied with Shōno Shōunsai, the first Living National Treasure in bamboo arts. In 1958 he was apprenticed to Tanabe Chikuunsai II, and that same year his work was admitted to the Hyōgo Prefecture Exhibition and the Japan Modern Arts and Crafts Exhibition, where he won the Yomiuri Television Broadcast Award. In 1978, he was admitted to Nitten for the first time and subsequently four more times. In 1985 he was selected by the city of Shinoyama as an Intangible Cultural Asset. He won numerous awards, including in 1990 being honored with the Award of Excellence and the Japan New Craft Arts Award. He became a member of the Japan New Craft Arts Association in 1992 and won the International Art and Peace Award from Geijutsu Kōron Publications, Inc. Since that time he has held a number of solo exhibitions at department stores and won the Superior Award at the Kyoto Craft Arts Exhibition.

About working with bamboo Minoura says, "Bamboo has a certain tenderness, a breathing quality. When you weave it and pattern it light passes through it; it is transparent and solid at the same time. It also retains the qualities it has in nature, flexibility and strength, with the ability to spring back into shape whenever you bend it. In winter the bamboo bends right down under the snow. When spring comes again and the snow melts, the bamboo leaps back up as if nothing has happened.

"Today a good craft work must have both beauty and practical merit. Thanks to the efforts of artisans in the past, there are many who now see bamboo flower baskets as art. However, some of us bamboo craftsmen still remain in the Edo period, crafting baskets for tea ceremonies or utensils for everyday use. I believe that developing new concepts and techniques, learning to be more creative in bringing to life an already beautiful material, should be our focus today in bamboo arts."

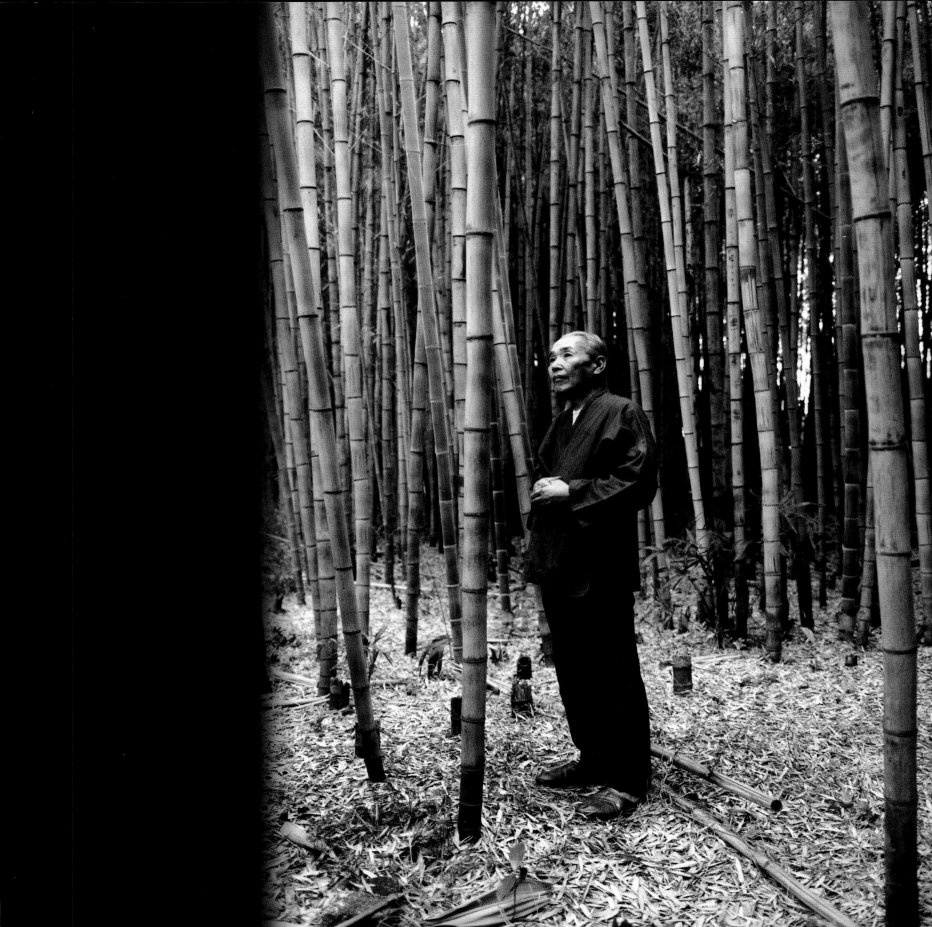

Minoura Chikuho

COLOR OF LIGHT, 1980 27" x 15" x 3" (69 x 38 x 8 cm)

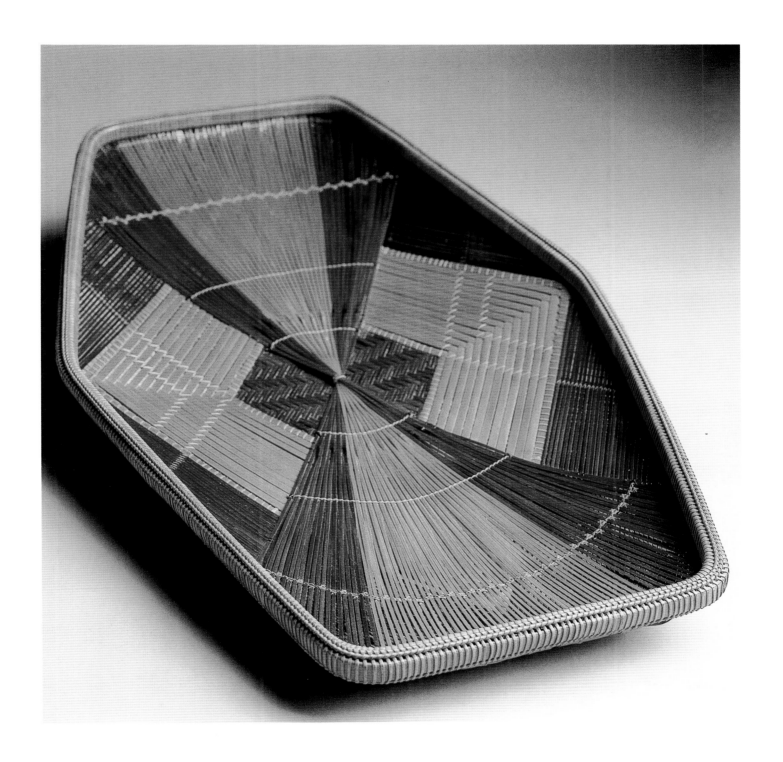

Minoura Chikuho

BUTTERFLY, 1979 21″ x 9″ x 15 1/2″ (53 x 23 x 39 cm)

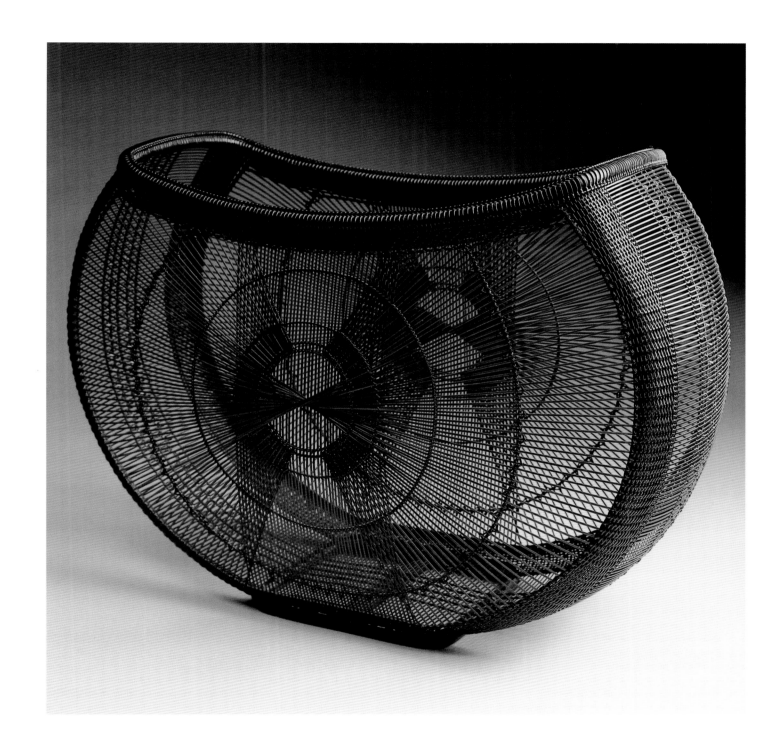

Shōno Tokuzō
born 1942, lives in Ōita prefecture

Shōno Tokuzō, born in Ōita prefecture, graduated in 1964 in Sculptural Arts from Musashino Art University. Upon his return to Ōita he apprenticed with his father, Shōno Shōunsai, the first Living National Treasure in bamboo arts.

After the death of his father in 1974, Shōno was commissioned by the Office of the Prime Minister to make a special white bamboo flower vase to be displayed at the Official Guest House in Tokyo. In 1975, he held a solo exhibition at the Tokiwa Department Store, other solo exhibitions followed, and in 1979 he was admitted to Nitten for the first time. He has been admitted every year since. In 1984 and 1998 he received the Grand Prize at the Japan New Craft Arts Exhibition, which led to his full membership in the organization. In 1984 he was invited to exhibit at the Japan-China-Korea Exchange. He won a Grand Prize at Nitten in 1999, and took an important step towards becoming a full Nitten member.

He describes his process in working with bamboo: "The beauty of the material itself is a very important aspect. I do the entire process of preparation by myself for this reason, so that I can have greater control over what I am working with. I use the bamboo that grows in the mountains near my home, and I process it in a traditional manner. I cut my own bamboo during the cold winter days of January or February. Then I stand it in a well-ventilated place for a hundred days or so to dry. After that I leach out the oil and sugar content by heating it over a flame and repeatedly wiping. The bamboo is dried further in a special hot chamber for twenty days. After this it carries a clean ivory color and the luster is greatly increased. It's a painstaking process. In my mind, as I compose the work, I carry an image of 'transparency,' like a work of clear glass. The purity of the bamboo is what I am looking for, to express the beauty of 'openness' in the work. I want to create something that is original and filled with energy. It is too easy in bamboo arts to become focused on technique. My good fortune was to have studied art at university

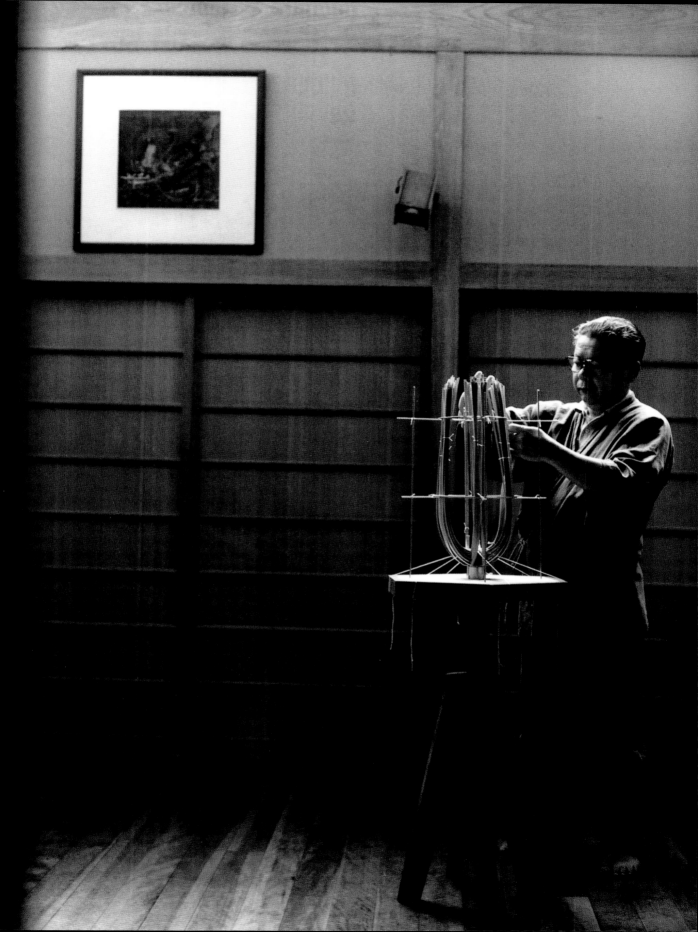

Shōno Tokuzō

PEONY, 1995 19″ x 16″ x 12″ (48 x 41 x 31 cm)

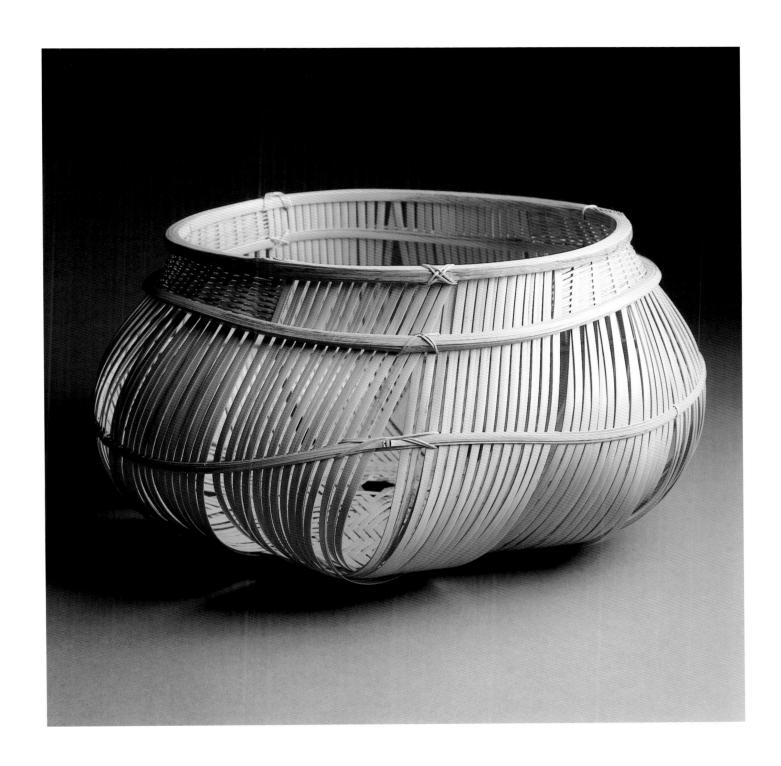

Suemura Shōbun

born 1917, lives in Osaka

Suemura Shōbun was born in Osaka, graduated from Imamiya Junior High School, and then was apprenticed to Yamamoto Shōen for five years. He was the only apprentice trained by Yamamoto. When Yamamoto died in 1941, he became independent. During the war he was drafted to work in a factory and continued doing this for a short period of time after the war.

Beginning in 1951 Suemara exhibited at Nitten for the first time, and subsequently for thirty-six times. He has won several awards at the Kansai Exhibition and the Osaka Craft Arts Association Exhibition. In 1962 he was admitted to the Japan Modern Craft Arts Exhibition and became a full member after winning ten times consecutively. He later exhibited work as part of a modern craft arts exhibition, sponsored by the Minister of Foreign Affairs, which traveled to major cities in the U.S. and to Europe, the South Pacific, South Africa, and Australia. The City of Osaka gave him an award of appreciation in 1973. He then became a trustee, judge, and honorary member of the Japan New Craft Arts Association. He has held over forty-five private exhibitions of his art.

Suemura says of his work, "I like working with black bamboo from Kyushu, which traditionally has been used for making fishing poles. The nodes create a pattern in the finished work that I find very beautiful. I always want to do my best to make something beautiful from bamboo. The problem for me is that the things I find in nature are always more beautiful than anything I could create. For the past thirty years, I have been collecting seashells. They are much more beautiful to me than anything I have made as an artist. In a way, this realization continuously challenges me."

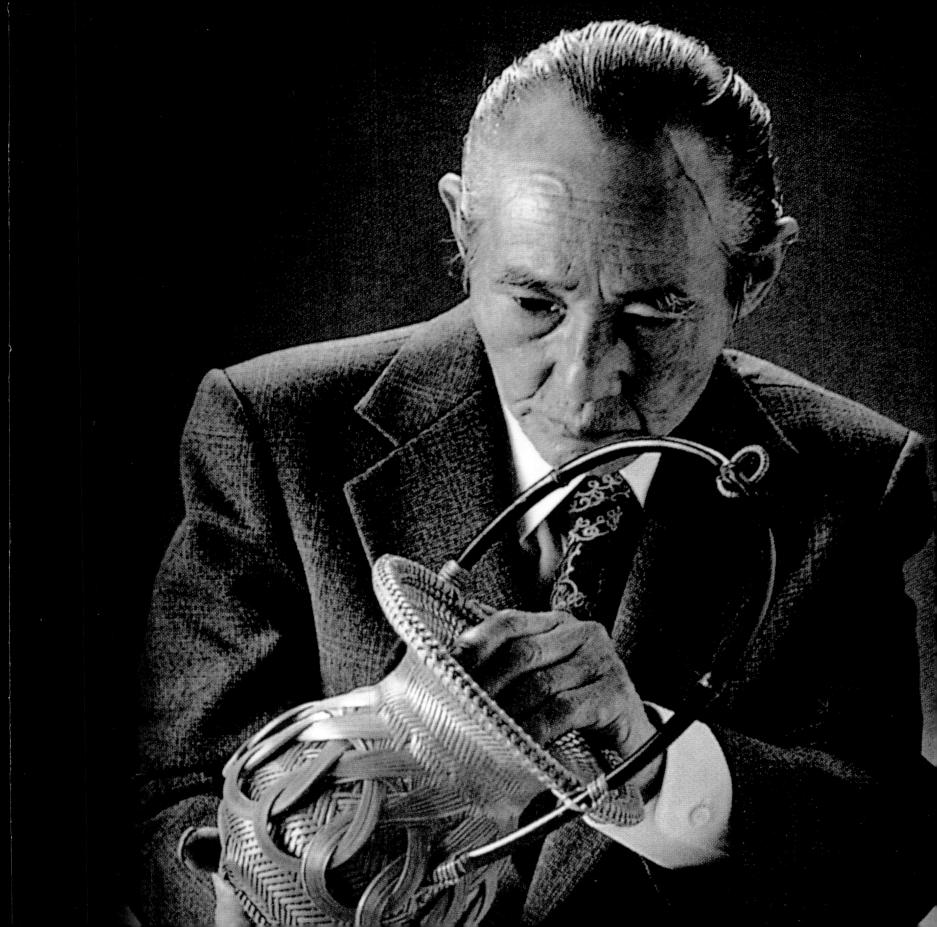

Suemura Shōbun

FOUR SEASONS, 1992 16" diameter x 10" (41 x 25 cm)

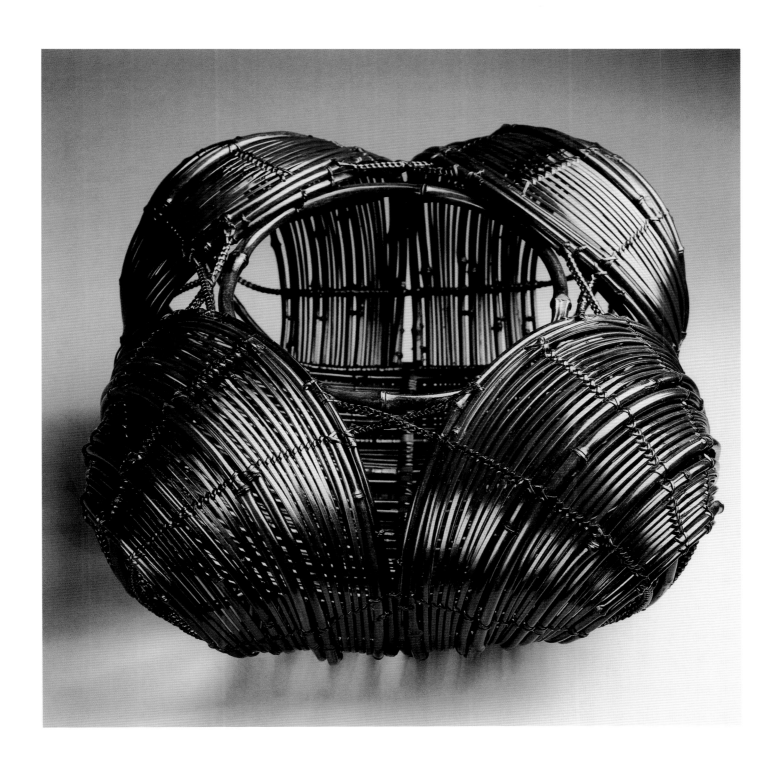

Suemura Shōbun

BIG FISH CATCH, 1978 43″ x 19″ x 10″ (109 x 48 x 25 cm)

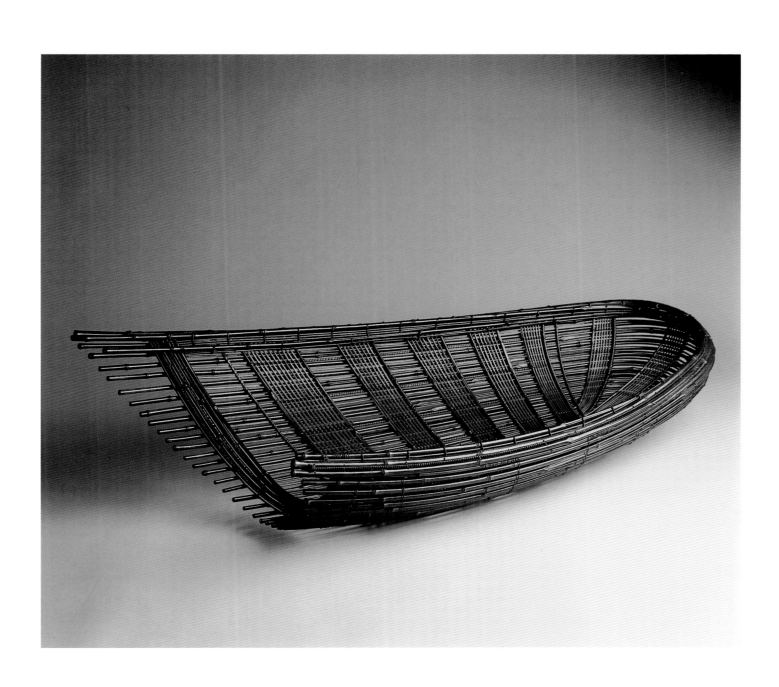

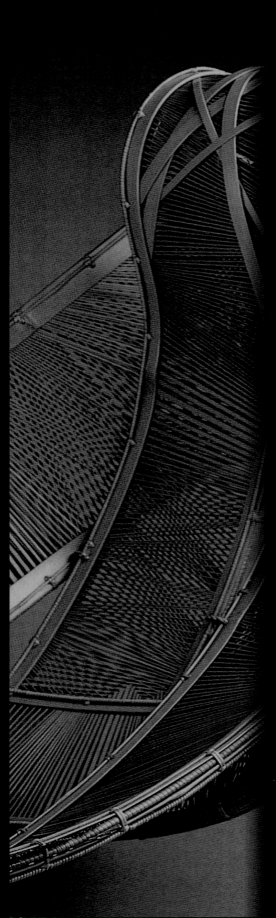

Torii Ippō

born 1930, lives in Aichi prefecture

Torii Ippō was born in Nishio City, Aichi Prefecture and began his career in bamboo arts in 1951 at the age of twenty-one, after his father's death. There was no choice for him, since the family business was the only means of support for his family. He taught himself making copies of his father's baskets. In 1957 he won the Tokyo Governor's Award at the Japan Flower and Tea Ware Craft Arts Exhibition. He was admitted to the Japan Modern Craft Arts Exhibition for the first time in 1980, and since then has been admitted eight times. In 1981 he was admitted to Nitten and since then has been admitted seventeen times. He was honored with the Chūnichi Newspaper Award at the Japan Modern Craft Arts Exhibition in 1982. In 1987 he became an official member of the Japan Modern Craft Arts Association and won a Members Award that year and again in 1991. In 1992 his work was selected for an exhibition of Japanese modern craft arts that traveled to Germany. Since 1993 he has been a judge of numerous exhibitions, including the Japan Modern Craft Arts Exhibitions as well as for regional competitions.

A story he tells: "I found a catalogue when I was rearranging my bookshelves the other day, an exhibition catalogue of treasures housed in Nara's Shōsōin Temple. It was the second public exhibition after the war of these national treasures, displayed at Tokyo National Museum in 1959. I had gone to Tokyo that year to visit some business associates and by chance I went to see the exhibition. At the time, I was a novice to this craft and was wondering if I should continue. I remember how that day my eyes stopped at a bamboo basket that was said to have been used as a flower basket for the memorial service of Emperor Seimu in 757 A.D. The basket was rather flat-shaped and it had remained in perfect condition for over 1200 years. Its power instantly charmed me. I recalled that moment over forty years ago as if it were yesterday. It determined my career as a bamboo artist."

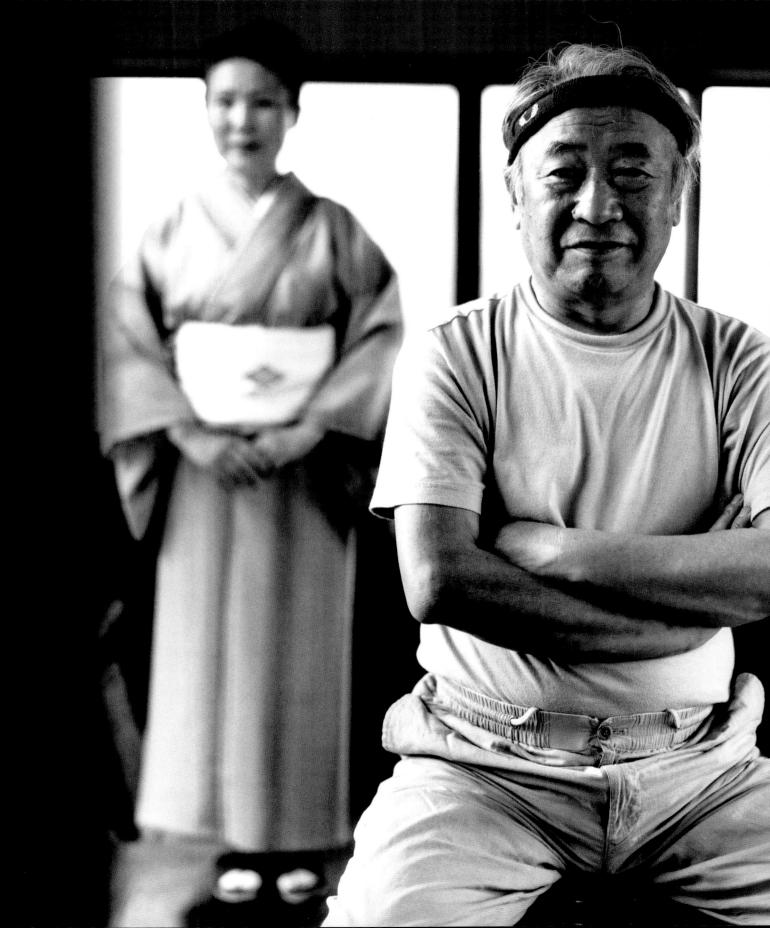

Torii Ippō

CRASH OF WAVES, 1996 19″ x 13″ x 25″ (48 x 33 x 64 cm)

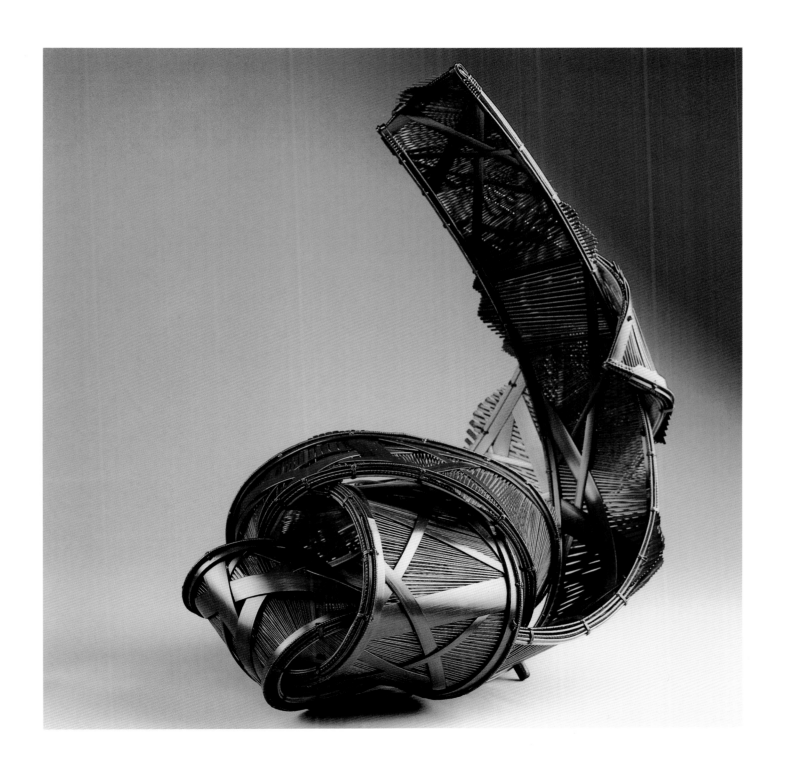

Torii Ippō

DOUBLE WAVES, 1990 33″ x 19″ x 16 1/2″ (84 x 48 x 42 cm)

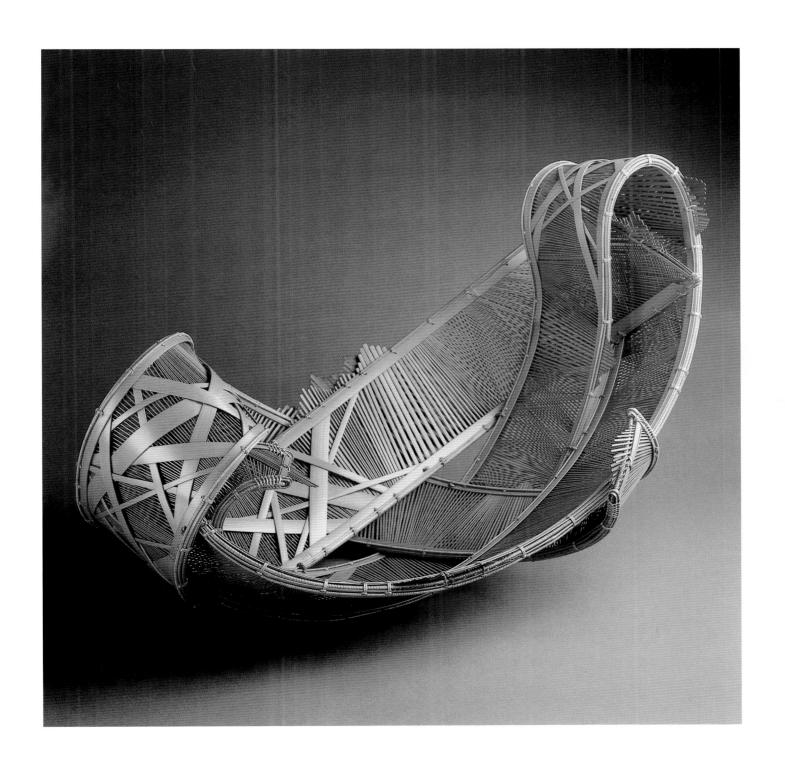

Yamaguchi Ryūun
born 1940, lives in Ōita prefecture

Yamaguchi Ryūun was born in Saga prefecture and graduated in bamboo craft from the Beppu Vocational School in 1957. At the age of twenty-three he was apprenticed to Living National Treasure Shōno Shōunsai. In 1967 won the Award of Excellence at the New Work Exhibition for Bamboo Products.

Numerous awards and honors followed including Beppu City Mayor's Awards and Ōita Prefecture Governor's Awards. He was admitted to the Japan New Craft Arts Exhibition in 1987 and since has been admitted ten times. In 1990 he was included in the Paris Top Artists Award competition, and in 1993 he won the Northern Kyushu Private Art Museum Award at the Japan New Craft Arts Exhibition. He was admitted to Nitten for the first time in 1994 and again in 1997. He has twice won the Ōita Art Association's Best Award.

From his studio in Ōita he says, "Frankly speaking, I never thought of the possibility of being an artist until I apprenticed with the first Living National Treasure in bamboo arts, Shōno Shōunsai. His example deeply inspired me to express myself. Even now, it is a great struggle for me with each new piece. I feel the beauty of the flowers. I feel the beauty of water flow. I try to bring that flow into my pattern. At first I was very surprised that people wanted to collect my work in the West, but now it has given me more confidence as an artist."

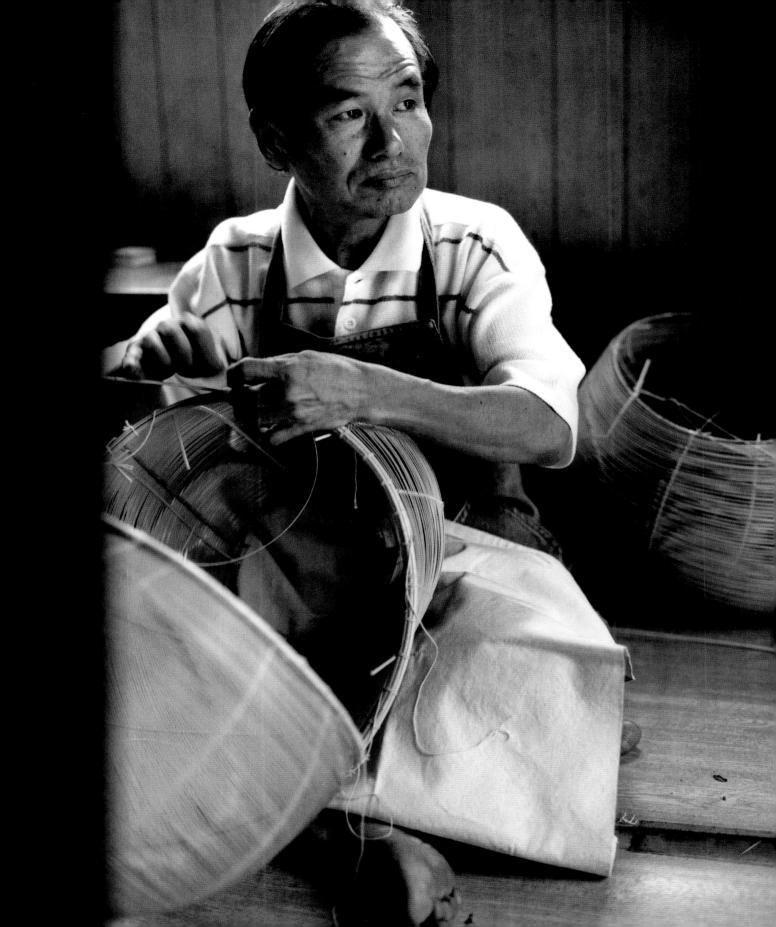

Yamaguchi Ryūun

WHITE WAVE, 1992 22" x 14" x 22" (56 x 36 x 56 cm)

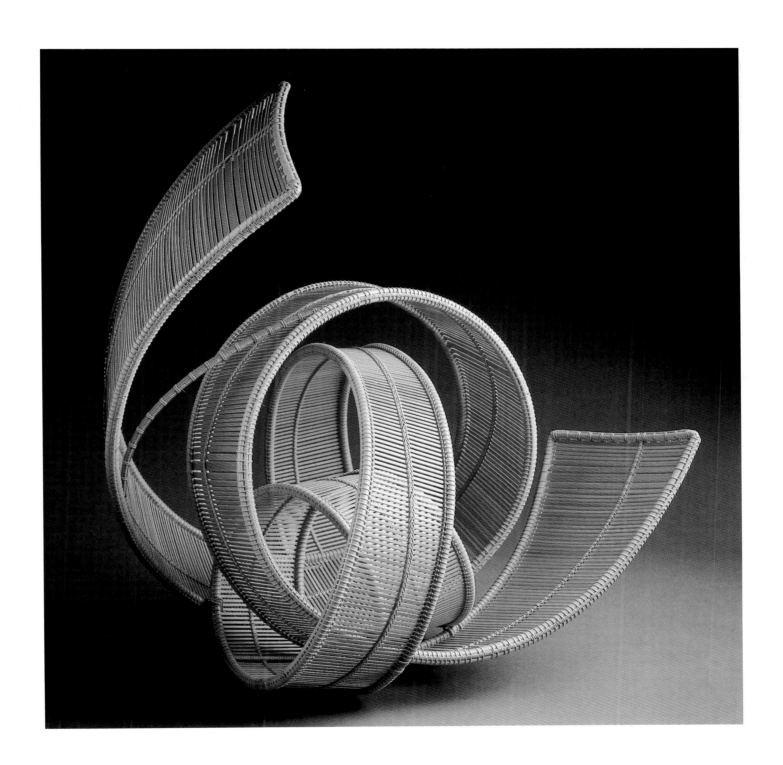

Yamaguchi Ryūun

SIGN OF WIND, 1999 14 1/2″ x 12″ x 6″ (37 x 31 x 15 cm)

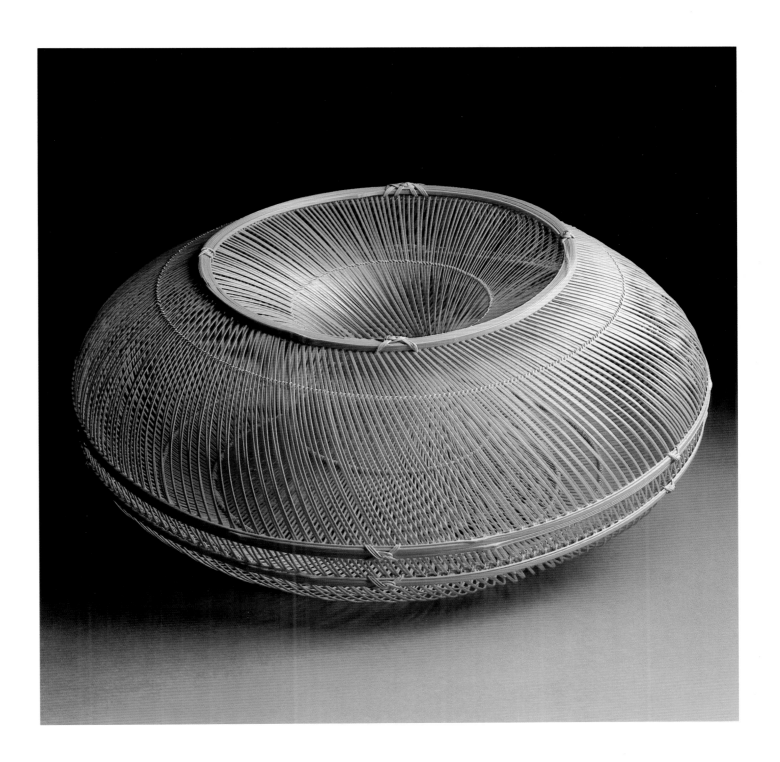

An Independent Artist

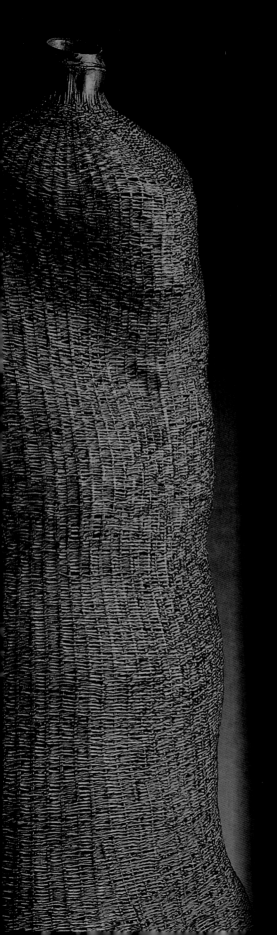

Nagakura Kenichi
born 1952, lives in Shizuoka prefecture

Nagakura Kenichi was born in Shizuoka City and after completing high school, learned the traditional art of *yūzen* dyeing (a multi-colored paste resist process). After a few years, he became dissatisfied with this and decided to learn bamboo basket making by working with his grandfather. He worked diligently to master the techniques but soon realized that breaking away from traditional forms was his goal.

In 1982 he held his first solo exhibition at Takei Gallery, in Numazu. Numerous solo and group exhibitions followed at department stores, galleries, and museums, in Tokyo, Kyoto, Osaka, Nagoya, Gifu, Hamamatsu, and elsewhere, including Bourgogne, France. He is an independent artist by choice, unaffiliated with any of the craft arts organizations.

He explains his approach by saying that he has always been very interested in European art, and modern American art, including the Pop Art movement. He also studied the work of other cultures, which led him back to examine primitive indigenous forms, such as the energetic cord-patterned pottery works from the *Jōmon* period in Japan, 3rd and 2nd millennia B.C. His most innovative works are based on naturally occurring shapes such as fallen leaves, emerging shoots, roots, cocoons, and decaying apples.

He acts quickly on his materials with an intuitive energy, saying, "I want to reduce the complexity of my feelings into my work like a poet does when writing a haiku. For me it is very important that I can use parts of a bamboo plant from above ground and parts from below ground. I like to add bamboo roots to some of my work as a reminder of the dark side of life. This creates greater harmony.

"I feel that the role of the artist is to revitalize the stagnation that comes into people's lives. I want to stimulate people to reconsider their relationship to the world. This is a source of inspiration for me."

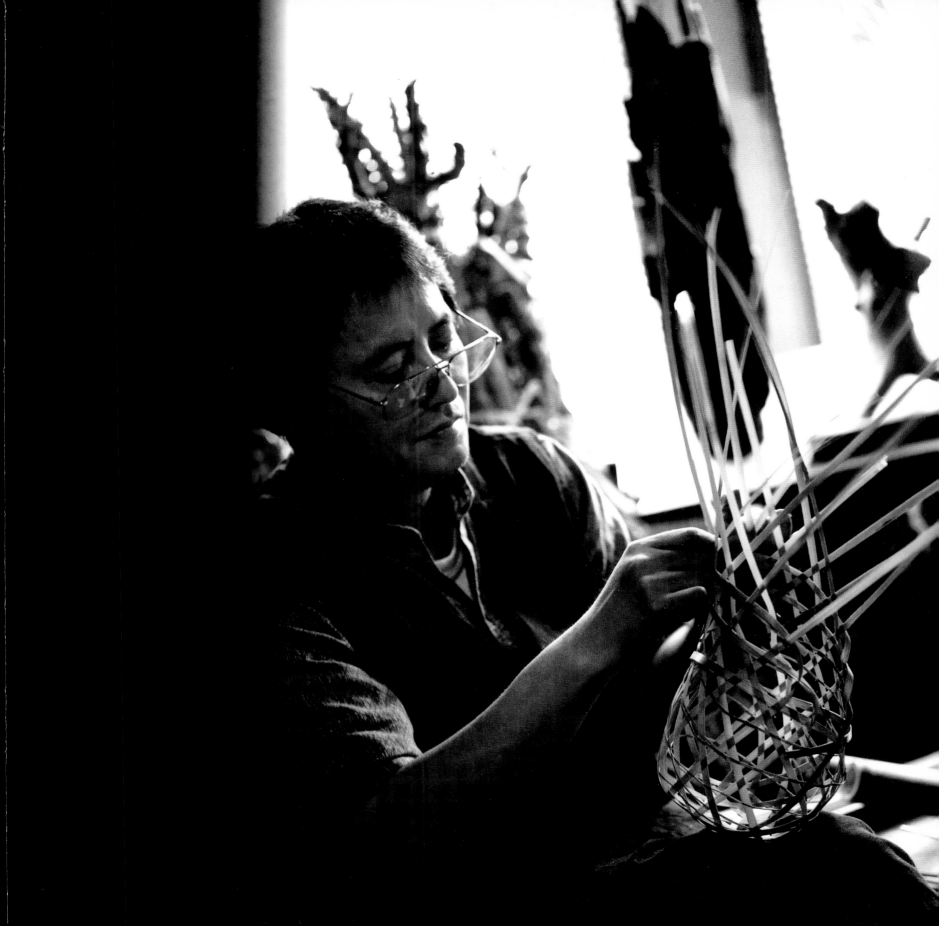

Nagakura Kenichi

NET, 1999 23″ x 15″ x 12 1/2″ (58 x 31 x 32 cm)

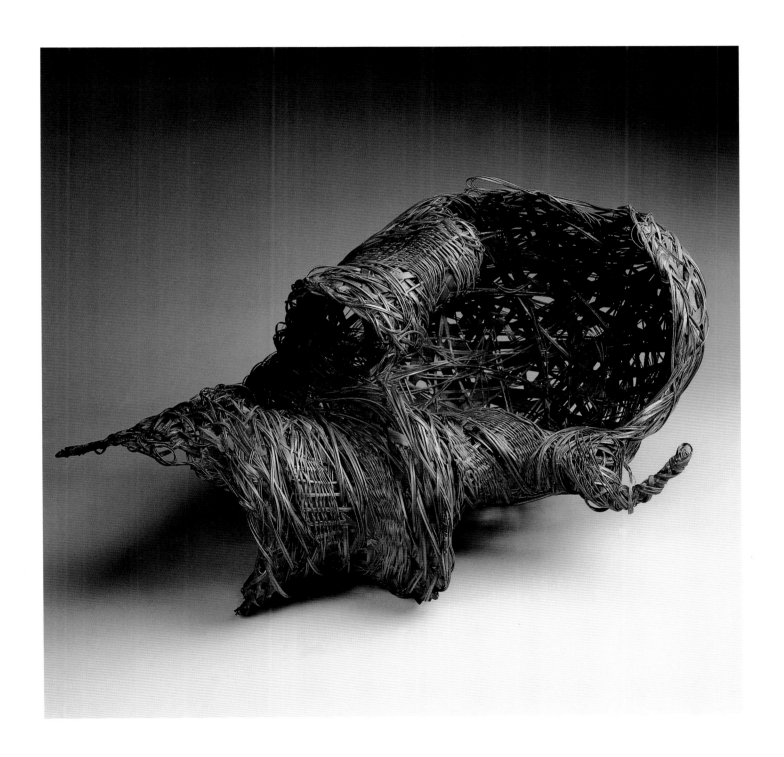

Nagakura Kenichi

HUMAN BEING, 1999 10″ x 8″ x 23″ (25 x 20 x 58 cm)

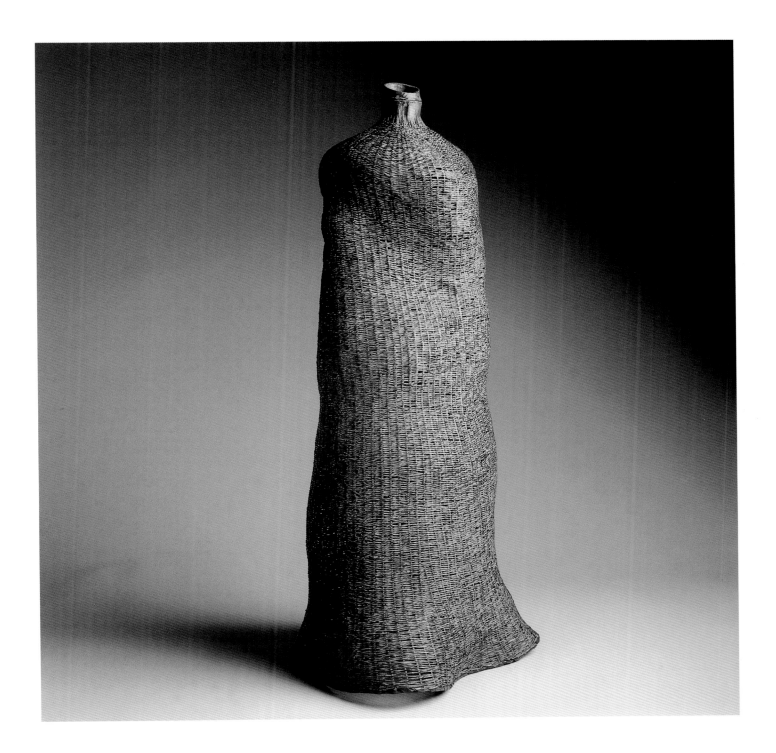

Bibliography

Coffland, Robert T. "Japanese Bamboo Arts." *Arts of Asia,* Volume 29, Number 2, 1999.

Coffland, Robert T. "Energy and Strength in Balance: The Bamboo Basket Art of Fujinuma Noboru." *Orientations,* Volume 30, Number 2, February 1999.

Cort, Louise Allison, and Nakamura Kenji. *A Basketmaker in Rural Japan.* Washington D.C. and New York: Smithsonian Institution and Weatherhill, 1994.

Cotsen, Lloyd, Janet Koplos, Patricia J. Graham, Hiroko Johnson, and Moroyama Masanori. Edited by Joseph N. Newland. *Masterworks of Form and Texture: Japanese Bamboo Baskets.* Los Angeles: Cotsen Occasional Press, 1999.

Farrelly, David. *The Book of Bamboo.* San Francisco: Sierra Club Books, 1984.

Kahlenberg, Mary Hunt, and Mark Schwartz. *A Book About Grass: Its Beauty and Uses.* New York: E.P. Dutton, 1983.

Kaneko Kenji and Moroyama Masanori. *Take no kogei: kindai ni okeru tenkai* (Modern bamboo craft: Developments in the modern era). Tokyo: Tokyo National Museum of Modern Art, 1985.

McCallum, Toshiko M. *Containing Beauty: Japanese Bamboo Flower Baskets.* Los Angeles: UCLA Museum of Cultural History, 1988.

Oster, Maggie, with Mark Seelen and Yi-An Chou. *Bamboo Basket: Japanese Art and Culture Interwoven with the Beauty of Ikebana.* New York: Viking Studio Books, 1995.

Sekijima, Hisako. *Basketry: Projects from Baskets to Grass Slippers.* New York: Kodansha International, 1986.

ROBERT T. COFFLAND first visited Japan in 1982. He has curated with his wife, Mary Hunt Kahlenberg, two exhibitions in Japan on American Indian and African art. Their TAI Gallery is involved in developing and curating public and private art collections in the United States, Europe, and Asia. Coffland is a writer and researcher on Japanese bamboo arts, and currently serving as the chairman of the New Mexico Arts Commission. He lives in Santa Fe, New Mexico.

PAT POLLARD studied photography at Columbia College, Chicago. As a commercial photographer on the East Coast, she won numerous awards for her work. Pollard was the photographer for *The Extraordinary in the Ordinary: Textiles and Objects from the Collections of Lloyd Cotsen and the Neutrogena Corporation* and *Masterworks of Form and Texture: Japanese Bamboo Baskets.* She is also an artist who works in mixed media. Pollard lives in Rancho de Taos, New Mexico.

ART STREIBER is a freelance photographer who specializes in travel, reportage, and entertainment portraiture. His subjects include Kevin Costner, Drew Barrymore, Michael Jordan, George Lucas, whose names were unfamilar to the bamboo artists featured in this book. Streiber is a regular contributor to *Vanity Fair, In Style, Time, W, Town & Country,* and *Departures.* He lives in Los Angeles.